Ancient
Light

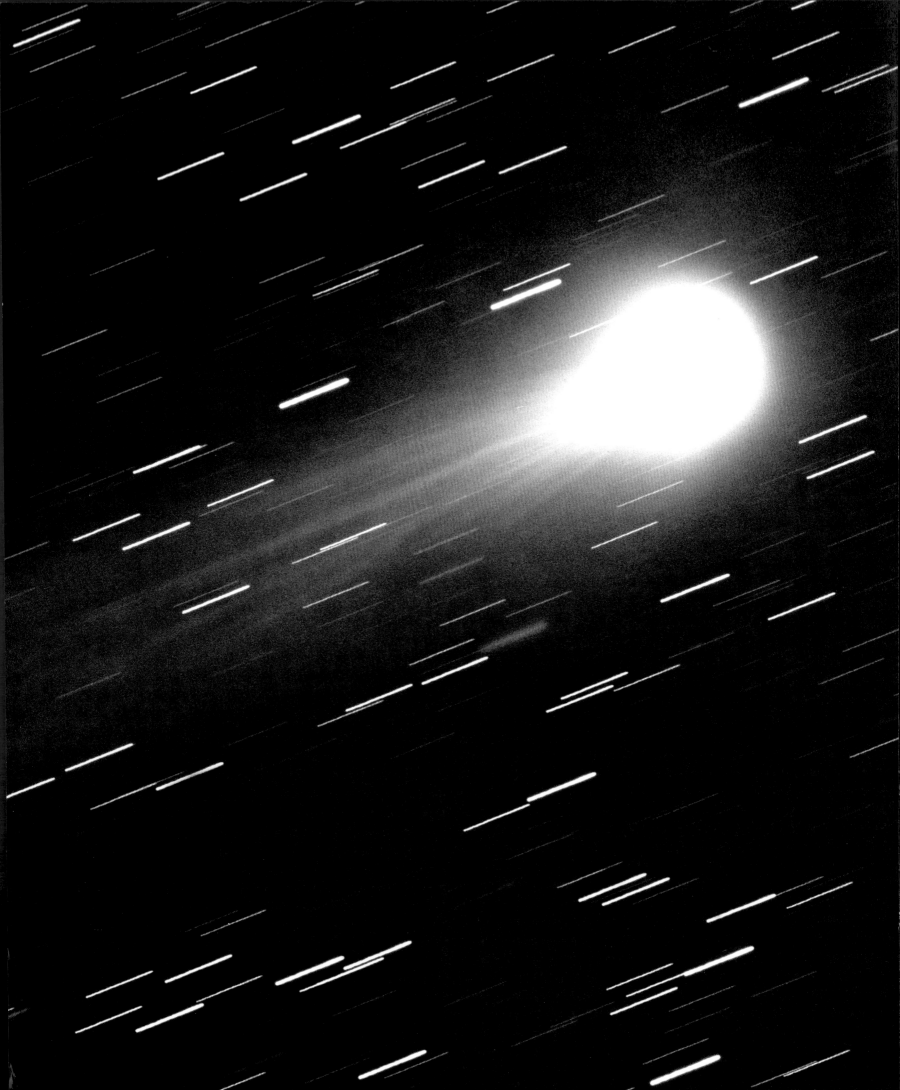

Ancient Light: A Portrait of the Universe

David Malin

Φ

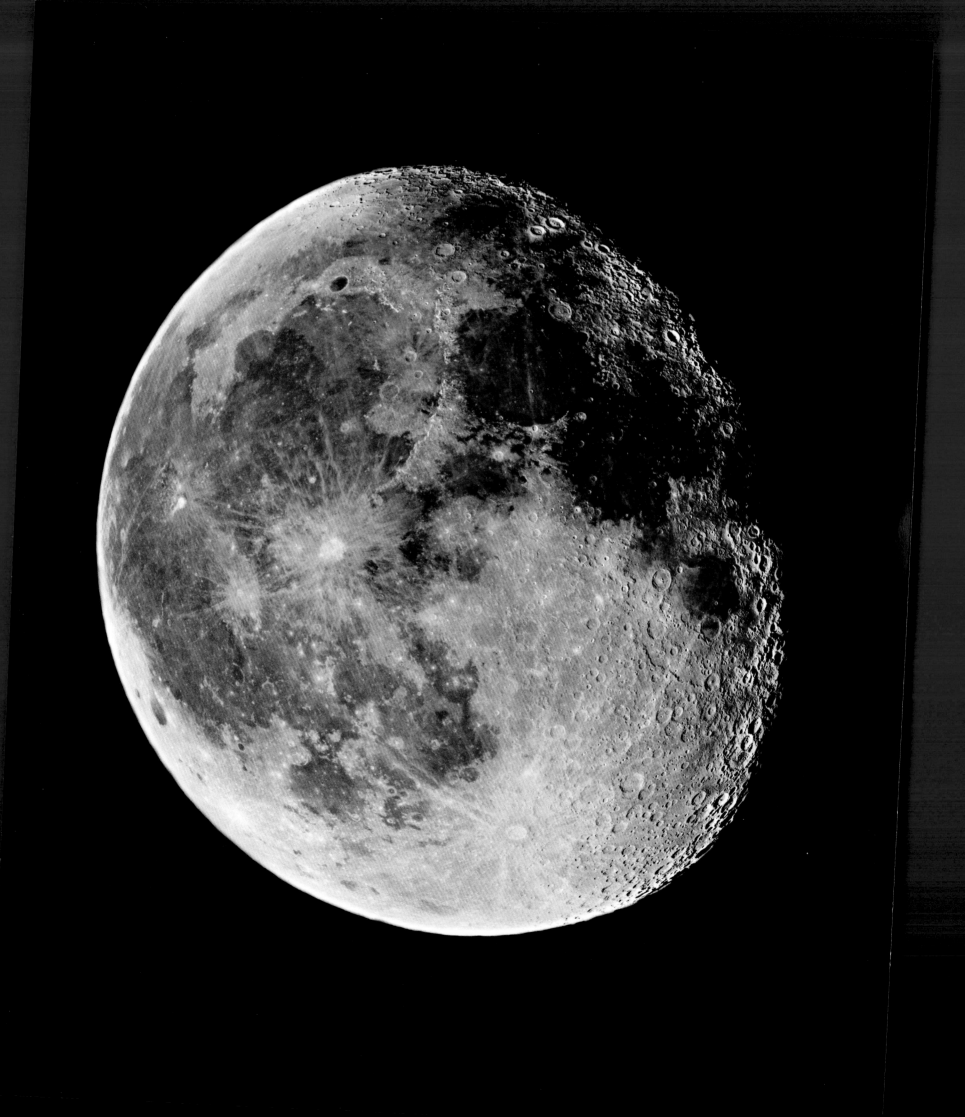

Capturing Ancient Light

Seeing in Black and White

>

For most of human existence, looking at the night sky has not been a colourful experience. It is more so now, of course, because we mostly live in brightly-lit cities and suburbs and, should we trouble to look skywards at night, the sky is tinged orange or green from the reflected glow of sodium- or mercury-vapour street lights. The stars are mostly invisible. Even away from this profligate waste of energy, beneath the velvet blackness of the naturally dark night sky, colour seems almost completely absent. A few yellowish stars and planets are seen but most appear as pale, colourless points of light. The first time I saw a truly dark sky like this was in Australia, after I joined the Anglo-Australian Observatory as its photographic scientist in 1975. It was a profound, literally eye-opening experience; there are no skies as clear or as dark in Britain or much of the rest of the world.

The stars are coloured of course; the hottest are as blue as the bluest daytime sky, the coolest as red as the glowing embers of a camp fire. We cannot, however, see these delicate hues with the dark-adapted eye. Using a telescope, or binoculars, does not reveal much colour either, as it is human vision that is lacking. Our long evolution has provided us with eyes sensitive enough to walk at night by the feeble light of the moon, which is almost a million times fainter than sunlight, but for this we have sacrificed both colour vision and visual acuity under low light-level conditions. There is no evolutionary advantage to be gained from admiring the colours of the stars, so night vision is essentially monochromatic.

If I have a reputation in astronomy, it is for a series of colour images of galaxies and nebulae I made after I joined the Anglo-Australian Observatory. These pictures were widely published and were among the first to show very faint objects in their true colours. However, these photographs began life as black and white glass negatives, taken with the observatory's telescopes. To create colour images, I had to undertake a number of distinct, specialized and essentially monochrome procedures. I made three separate exposures of the sky with special black and white plates and filters to record blue, green and red light as separate negatives. These images were later combined in the lab to make colour pictures, a technique that is trivial using today's digital software but was much more challenging using wet darkroom techniques.

This process worked well for me because I had enjoyed a long affair with black and white photography. To me, black and white is the essence of photography; it is about light and shade, shape, texture and the subtlety of tone. All these ingredients exist in a colour photograph, but black and white allows their full expression. Extracting this magic in the dark, with the smell of chemicals in the air, is a weird way to make anything as powerful as a photograph, but it is

still more satisfying than using software and the result a more personal statement. However, I was an early convert to Adobe Photoshop in 1993, at first mainly to produce web pages and later because it offered more creative possibilities, and have not made a photograph in a darkroom since 2001. However, while I work in colour a lot, exploring high-resolution files of my old black and white images is still a pleasure.

When photography was invented in Paris in 1839, it was soon remarked that the daguerreotype's lack of colour was something of a disadvantage. However, the response was similar to that which greeted the appearance of black and white television in the 1950s; it was the fact of photography that was celebrated, not its deficiencies. Louis Daguerre was persuaded by François Arago, a noted physicist and astronomer and a member of the French parliament's Chamber of Deputies, to make his marvellous invention public and to accept a generous lifetime pension from a grateful nation.

Within weeks of Arago's announcement, the renowned astronomer John Herschel also became aware of Daguerre's process and promptly made his own photographs, among which was a picture of the famous 40-foot telescope constructed by his father, William. Like Arago, Herschel immediately appreciated the importance of the new process of photography for science and astronomy and, again like Arago, did not mention the lack of colour reproduction, probably because he did not expect to find colour among the stars.

Herschel was interested in chemistry as well as astronomy and in 1819, long before photography was invented, had found that a solution of sodium hyposulphite would dissolve silver salts, normally quite insoluble in anything. This solution was hypo, now known as sodium thiosulphate and still used as a photographic fixing agent. The use of hypo in photography was the key to preserving photographic images and Daguerre soon adopted it, greatly improving his process. Herschel himself also invented a photographic system that has survived into modern times. Herschel called it the cyanotype but it is best remembered as the 'blueprint process', a simple way of making contact copies of large drawings on paper or any translucent material. The first photographically illustrated book ever published was a scientific tome on British algae, written and produced with full-page cyanotypes by Anna Atkins, who knew Herschel well (Anna Atkins, *Photographs of British Algae: Cyanotype Impressions*, privately published in 12 parts, 1843–53). This preceeded William Henry Fox Talbot's much better known *The Pencil of Nature* (1844) and marked the beginning of books illustrated with photography.

Photographing the Night Sky

>

Given his familiarity with the subject, it is at first surprising to learn that Herschel did not use photography in any of his astronomical activities. This was mainly because, from 1839 until his death in 1871, he did little astronomical observing. However, it was also the case that early photographic processes were too insensitive and practically difficult to use in this context. Victorian photographers had to prepare their own wet, light-sensitive plates as required. The plates had to be both exposed and processed before they dried out, which meant spontaneous photography, even in a studio setting, was almost impossible and photography outdoors required a portable darkroom. These complications, the insensitivity of the wet plates to faint light and the inability to make long exposures, meant that photography was little used by night-time astronomers until the 1880s. They used a new type of photographic emulsion, the so-called dry plate or gelatin process, invented by Richard M. Maddox in 1871. Within a few years this became a commercial product, available to all, first on glass, later on flexible film. It made photography widely available and easy to use for everyone, including astronomers.

Then, in September 1882, a brilliant comet graced the southern skies, bright enough to be seen during the day. David Gill, director of the observatory in Cape Town, commissioned a local photographer to attach his camera to one of the observatory's telescopes and photograph the splendid comet with a portrait lens. Gill was astounded by the vast number of stars the long exposure revealed and was intrigued that some stars looked brighter on the photograph than they did to the eye, and some fainter. A few months later, in early 1883, Andrew Ainslie Common, an English engineer and astronomy enthusiast, took a photograph of the Orion nebula with a telescope he had made himself. This 33-minute exposure revealed stars too faint to be seen by eye using the same telescope. Photography had been transformed from a way of recording the visible world into a detector of the unseen.

Generations of astronomers have struggled with the endless complexities and frustrations of this art-science since Ainslie Common's vital discovery in 1883. For images of stars to be sharp and round, the telescope has to follow them precisely as they are carried across the sky by the Earth's rotation and, until the 1970s, this was done manually, with the astronomer's eye fixed to an eyepiece, using knobs and levers to keep a guide star centred on some faint graticule for hours at a time. A moment's inattention or the sometimes irresistible urge to sleep could ruin an exposure, as could the arrival of clouds. Even more frustrating and unpredictable than cloud was the 'seeing', the endless trembling of the thermal layers in the Earth's atmosphere

through which starlight passes. Any significant change in temperature in the air above or around the telescope during the exposure will blur the image, sometimes irretrievably. This is one reason why ground-based telescopes are built on high mountain tops and why the Hubble Space Telescope is such a great success. But high mountains can be cold places at night and contact with the chilled brass, glass and steel of the telescope eventually penetrates to the very bones of even the best-dressed astronomer.

In contrast to the chill of the long winter nights was the humid air of the darkroom, laced with the pungent smell of Herschel's hypo. In most observatories the plates were processed on the night that they were exposed, one at a time, by hand, in total darkness. Though the process was designed to be as foolproof as possible, many hazards awaited the unwary or overtired astronomer. And most astronomers were seriously overtired at the end of a winter night – processing plates until well into the next morning – so foolproof was sometimes not enough.

Those days are now gone. I was one of the last to use glass plates on a large telescope and I processed my final plate almost 120 years after Ainslie Common had first shown what was possible. Since the 1970s, electronic autoguiders and computer-controlled telescopes have ensured that star images can be made consistently round. In addition, astronomical images are now made with digital detectors, which are much more sensitive than photographic plates. These tools are just as technically challenging to use, but the astronomer now spends the night in comfort in front of a computer monitor, which may or may not be on the same mountain, or even in the same hemisphere, as the telescope and is almost certainly out of sight of the stars.

A Portrait of the Universe
>
We have divided this book into sections, using the constellations as a framework to identify the positions of the images in the sky. The weird creatures and ancient mythologies represented by the patterns of the stars were formalized into precisely defined areas of the sky by the International Astronomical Union in the 1930s and our chapter-opening images map these boundaries over photographs made by the famous Japanese photographer Akira Fujii.

The astronomical images themselves are derived from large-format glass negatives (mostly 10 x 10 and 14 x 14 inch sizes) that were made for scientific purposes. Most of them were taken on the Anglo-Australian or UK Schmidt Telescopes in New South Wales, Australia. Time on a large telescope is too keenly sought to allow for snapshots or retakes, so each exposure was carefully timed, precisely pointed and tracked with unerring accuracy for

an hour or more; no mean feat with a camera that weighs hundreds of tonnes. The original glass negatives were coated with photographic emulsions specially formulated for astronomical photography, and were usually hypersensitized before exposure at the telescope, a process that might involve baking them in a moderate oven, exposing them to hydrogen gas or rinsing the plates in a dilute silver nitrate solution, all under laboratory conditions. These processes were based on recent scientific research and knowledge of photographic science: they gave the plates enormously enhanced sensitivity to faint light.

The selection of images in this book, however, quite intentionally reflects the earliest days of photographing the night sky. The Moon [see p 004 and p 018], a known quantity before the advent of photography, was the first astronomical object to be photographed, by the American photographer John Draper, in 1840. His son, Henry Draper, was also the first to photograph the Orion nebula in 1882, but he died before he could perfect the technique that months later allowed Ainslie Common to show how long exposures revealed ever fainter stars. With primitive photographic emulsions, imperfect telescopes and little understanding of the distance (and thus dimensions) of the fuzzy blobs that were being found in increasing numbers, it was impossible to distinguish proximate starforming regions from distant galaxies, or reflection nebulae from supernova remnants. Even in 1936, the term 'nebula' was used by no less a luminary than Edwin Hubble in his book *The Realm of the Nebulae*. Today we describe Hubble's nebulae as galaxies like the Milky Way [see overleaf], reserving 'nebulae' (from the Latin for 'misty') for gas or dust, emitting or reflecting starlight. Hubble knew the difference but tradition dies hard.

We have already mentioned the serendipitous appearance of a comet in the sky and its benign influence on David Gill and the progress of astronomical photography. The distances, if not the nature, of comets were well understood in the 1890s, and they are well represented here, including the most famous, Halley's Comet, during its 1985–86 apparition [see frontispiece and p 019–021]. We now know that the typical comet is a loose clump of dust and frozen gas, several kilometres in diameter, often in a wildly eccentric orbit that brings it close to the Sun from time to time. As comets warm they begin to evaporate, shedding dust and gas in long, sun-swept tails and develop a rounded head or coma that gives them their distinctive fuzzy appearance. Related to comets by mechanism, name and appearance, but not by size, are cometary globules. They are extremely faint and were first noted in 1976 on photographic plates from the UK Schmidt Telescope. They are opaque clouds drifting around the Milky Way trailing a long dusty tail that feebly reflects starlight. Recognizing Ainslie Common's remarkable breakthrough, we have also used several images of the Orion nebula. This famous nebula in Orion [see p 108 and p 109]

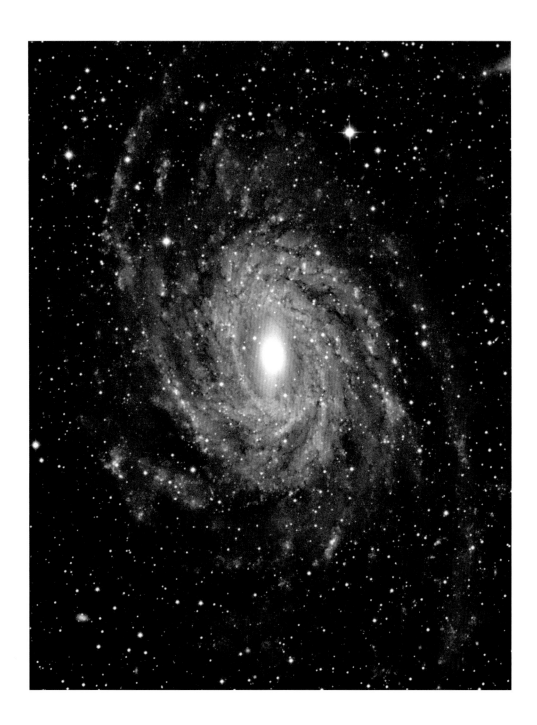

NGC 6744 in Pavo, a mirror
of the Milky Way

‹

This beautiful spiral galaxy is in the
southern constellation of Pavo (the
Peacock) and is at a distance of 25 million
light years. The faint spiral arms have
a clumpy appearance and are further
fragmented by dust lanes. The curved arms
contrast strongly with the bright, smoothly
structured nucleus, which is composed
of billions of faint stars, and is distinctly
elongated. Though many spiral galaxies
are described as resembling the Milky Way,
NGC 6744 is probably more like our own
galaxy than any other nearby systems.

is a tenuous cloud consisting mostly of hydrogen, shot through with traces of smoke-like particles. These originate in the stars themselves and in a large cloud are numerous enough to make it opaque, so that it blocks the visible light but not the radiant heat of stars beyond. It is in such cold, dark places that stars are formed and, as they begin to shine, illuminate and rewarm the surrounding gas and dust. The gas emits a pinkish glow, characteristic of hydrogen. An emission nebula, which is technically a plasma, is like the electrically stimulated glow of a neon sign; in space ultraviolet light from the stars is the stimulant. There are many examples of such starforming emission nebulae in these pages, because their endless complexity and visual variety is enhanced by dark globules of dust in the foreground and sometimes reflection nebulae, which is dust seen by scattered starlight.

Emission nebulae are also associated with the endpoints of stellar evolution. When a sun-like star reaches the end of its days it will eject a nebula with a distinctive circular symmetry, as in the Helix nebula [see p 037]. However, some, quite rare, stars have masses much greater than the Sun and have brilliant but comparatively brief lives, measured in millions rather than billions of years. They collapse to form supernovae, creating a flash of light that can, for a few days, be as bright as all the stars in a galaxy. A powerful pulse of energy also emerges that traverses the Milky Way. As it does so it excites the gas between the stars long after the supernova itself has faded. The Vela supernova remnant [see p 068–071] is an example of this.

Dust is an essential ingredient in a reflection nebula, the best example of which surrounds the stars of the Pleiades [see p 117]. This faint nebula was discovered on a photograph by another pioneer astrophotographer, perhaps the most productive and talented of all: Edward Emerson Barnard. Barnard specialized in using everyday plate cameras for wide-field images of the sky. In doing so he discovered what is now known as Barnard's Loop, pictured in my own wide-angle image [see p 114]. At the focus of the semicircular arc are the Orion and Horsehead nebulae [see p 109 and p 112-113], both of which feature in this book. Elsewhere we emphasize the structure of the dust in reflection nebulae associated with a single star, Rho Ophiuchi [see p 094 and p 095], or with many stars, as in the Corona Australis picture [see p 056]. These nebulae sometimes take on strange shapes as they are sculpted by the light of nearby stars, such as the Witch's Head or Hand of God nebulae [see p 103 and p 073].

As well as being surrounded by a fine reflection nebula, the Pleiades is a famous star cluster, recognized as such from antiquity and now known to be a group of young stars, perhaps 100 million years old. We illustrate here two other star clusters of vastly greater age. Omega Centauri [see p 093] and 47 Tucanae [see p 026–029] are included because they are the finest of their kind in the sky and they are in the southern hemisphere, so the Anglo-Australian telescope is well located to study them.

Much of astronomy is concerned with research into galaxies, which are vast assemblies of stars. The brightest galaxies here, such as the nearby spiral in Andromeda [see p 120 and p 123], contain hundreds of billions of them. Their combined gravity allows galaxies to retain the gas and dust from which new stars and planets may also form. By studying galaxies we learn about our origins and perhaps our destiny; the origins of the ingredients of life and the destinies of stars like the Sun and the planets associated with them. Much of our current knowledge on these subjects was gleaned from black and white photographs like those in this book.

Galaxy interactions are common and we include a few examples here. Perhaps the most visually appealing are the galaxies of the Antennae [see p 076]. This image was made on the Kitt Peak 4m Telescope in Arizona by another individual who advanced astronomical photography greatly but was neither an astronomer nor a photographer. Al Millikan was a photographic scientist with the Eastman Kodak Company and many of the images in this book were made on plates coated with emulsions designed by Millikan and his colleagues in the late 1960s. These plates were perfect for detecting the faintest features of galaxies, but they could also be used for more mundane photography.

The star trail picture opposite connects the planet on which we live with the stars above. It shows the trails of stars circling the south celestial pole, carried across the sky by the Earth's rotation. In the foreground is the dome of the Anglo-Australian Telescope. The star trails represent the old astronomy, the measurement of time and the position of the stars on the sky for everyday navigational, surveying and timekeeping. Within the dome is a telescope designed for the new astronomy. Its purpose is to understand the nature of the stars rather than their position. This telescope and others like it seek out galaxies of stars, far away in space and time, to learn what the universe was like long ago and, ultimately, how it came into existence.

This continuum of discovery began before photography was invented, but photography was an essential ingredient in over 100 years of astronomical progress and understanding. This book of black and white pictures is dedicated to that silver century.

Star trails around the
South Celestial Pole
>

As the Earth spins beneath the stars, a
long exposure photograph records their
concentric tracks across the sky. The star
trails seem to circle a fixed point on the
sky, which is the Earth's axis of rotation
projected into space. Had this photograph
been taken at the Earth's geographic
poles, this point on the sky would be
directly overhead, but from Siding Spring
Observatory in New South Wales, Australia,
it is about 30 degrees above the horizon,
reflecting the latitude of the Anglo-
Australian Telescope dome. The exposure
time for this image was over 10 hours
on a special, high-contrast astronomical
plate and it has been copied using a special
technique (unsharp masking) which
emphasizes the star trails but also produces
a halo-like artefact at contrast boundaries.

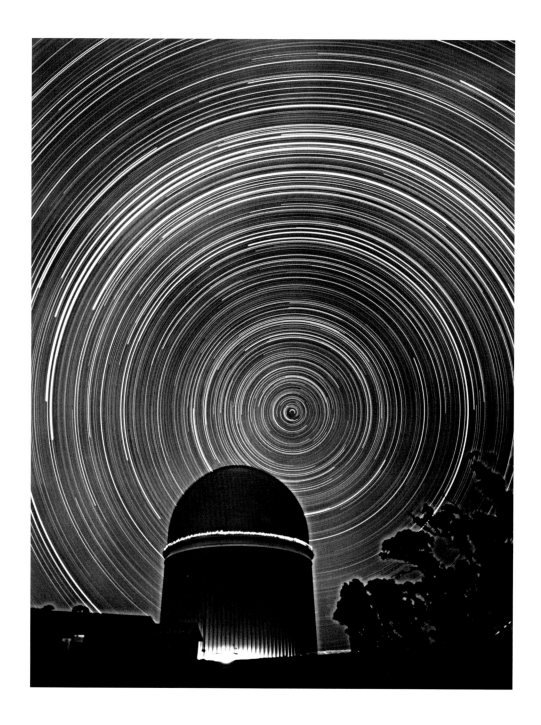

\>

It is only about 400 years since the Sun-centred solar system became the accepted model of our local universe, as the theories of Copernicus were confirmed by Galileo's observations and Newton's insight into the all-pervasive nature of gravity. The illustration here, from Peter Apian's *Cosmographia* (1524), shows a diagram of the earlier, Earth-centred view that had prevailed since at least the time of Aristotle (250 BC) and probably long before. Modern, ground-based telescopes are no longer built primarily to study objects in our solar system. Two hundred years ago they studied little else. Nowadays the Moon has been walked upon, while Mercury, Venus, Mars and some of the outer planets have been mapped in detail by satellites in orbit around them. However, occasionally, expected and unexpected visitors to the inner solar system appear and briefly attract the attention of amateur and professional astronomer alike. While Comet Halley appears at least once in every average lifetime (it returns every 75–6 years), it will be 100,000 years before we see Comet Hyakutake again. They are pictured in this section along with the scarred surface of the Moon, first noted through the telescope by Thomas Harriot and Galileo in 1609.

Around the Solar System

Dear Reader, Books by Phaidon are recognised world-wide for their beauty, scholarship and elegance. We invite you to return this card with your name and e-mail address so that we can keep you informed of our new publications, special offers and events. Alternatively, visit us at **www.phaidon.com** to see our entire list of books, videos and stationery. Register on-line to be included on our regular e-newsletters.

Subjects in which I have a special interest

☐ Art ☐ Contemporary Art ☐ Architecture ☐ Design ☐ Photography

☐ Music ☐ Art Videos ☐ Fashion ☐ Decorative Arts ☐ *Please send me a complimentary catalogue*

	Mr/Miss/Ms	Initial	Surname

Name

No./Street

City

Post code/Zip code Country

E-mail

Please delete address not required before mailing

Return address for USA and Canada only

PHAIDON PRESS INC.

180 Varick Street

New York

NY 10014

*Return address for UK and countries
outside the USA and Canada only*

PHAIDON PRESS LIMITED

Regent's Wharf

All Saints Street

London N1 9PA

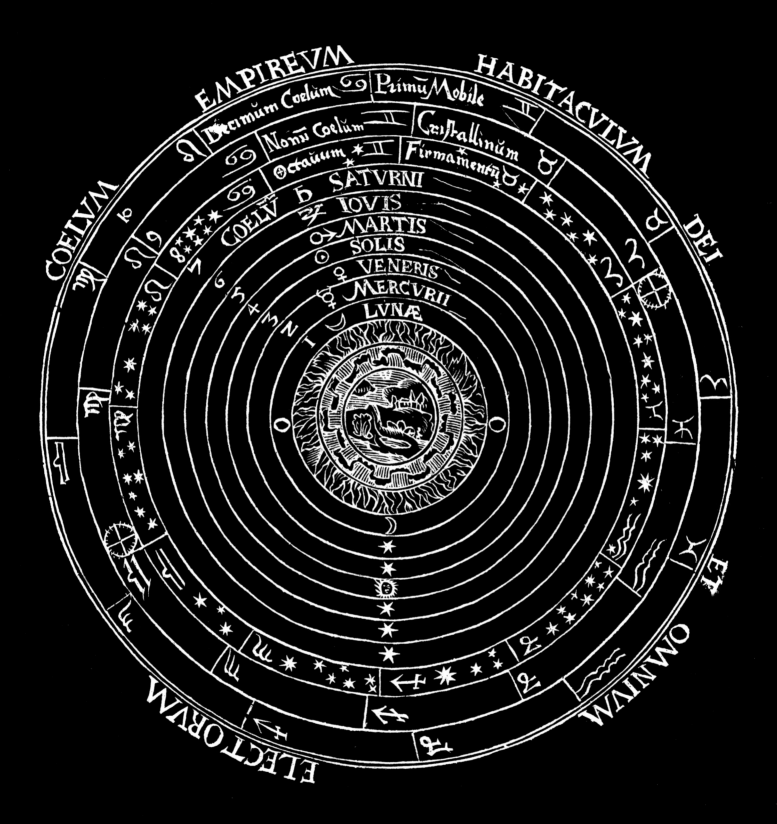

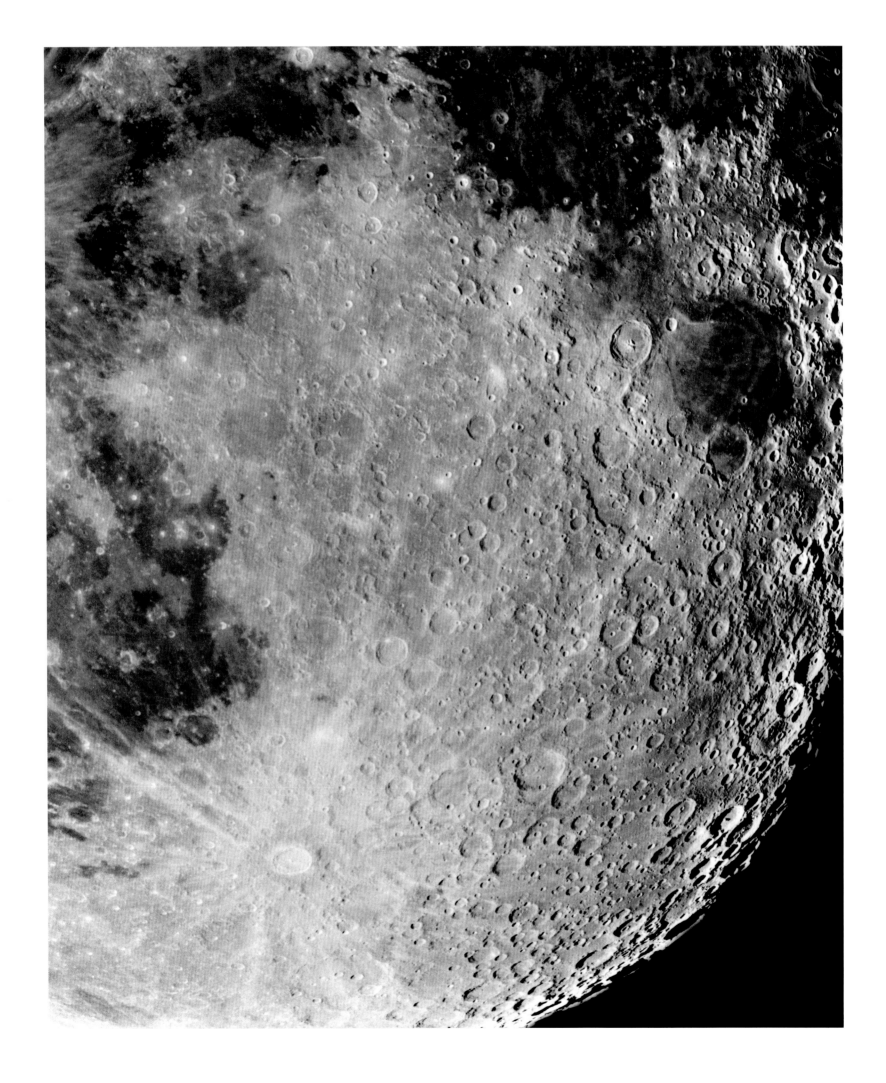

Around the lunar crater Tycho

<

The Moon was the first celestial object to be successfully
photographed, by John Draper in 1840. It was also the
first to be sketched (by Thomas Harriot, in 1609) after
the invention of the telescope, though Galileo published
his lunar drawings first (in 1610), to great effect. The
Moon's ancient, pitted surface shows a surprising variety
of texture, from the ancient, heavily cratered, light-
coloured highlands to the younger, darker lava seas of the
mare where younger impacts appear as pale splashes of
debris. While the Moon's ever-changing appearance and
stark contrasts make it a remarkable sight even in modest
binoculars, one of the most obvious telescopic features of
the Moon is the rayed crater Tycho, named after the
Danish astronomer Tycho Brahe, whose name is also
attached to a Martian crater. The lunar Tycho, created by
what must have been a huge impact, is in the Moon's
southern highlands and is relatively young, probably less
than 100 million years old. The crater itself is about
85 km in diameter and has a prominent central peak, just
visible here. Its distinctive, light-coloured rays of debris
extend for 1,500 km across the lunar surface.

Comet Halley, 12 March 1986

>

After a chilly sojourn in the outer solar system, Comet
Halley returned to the warmth of the Sun in late 1985
after an absence of 76 years. Comet Halley rounded the
Sun in February 1986 and was visible again to Earth-
bound telescopes in early March. At this time the comet
was at its most active and its dust tail very well developed.
This wide-angle image was made in blue light with the
UK Schmidt camera and special photographic techniques
reveal detailed structure in its long blue ion tail. The stars
are slightly trailed because the telescope was tracking the
comet for this 15-minute exposure, and the bright object
at the top of the frame is the globular cluster M75.

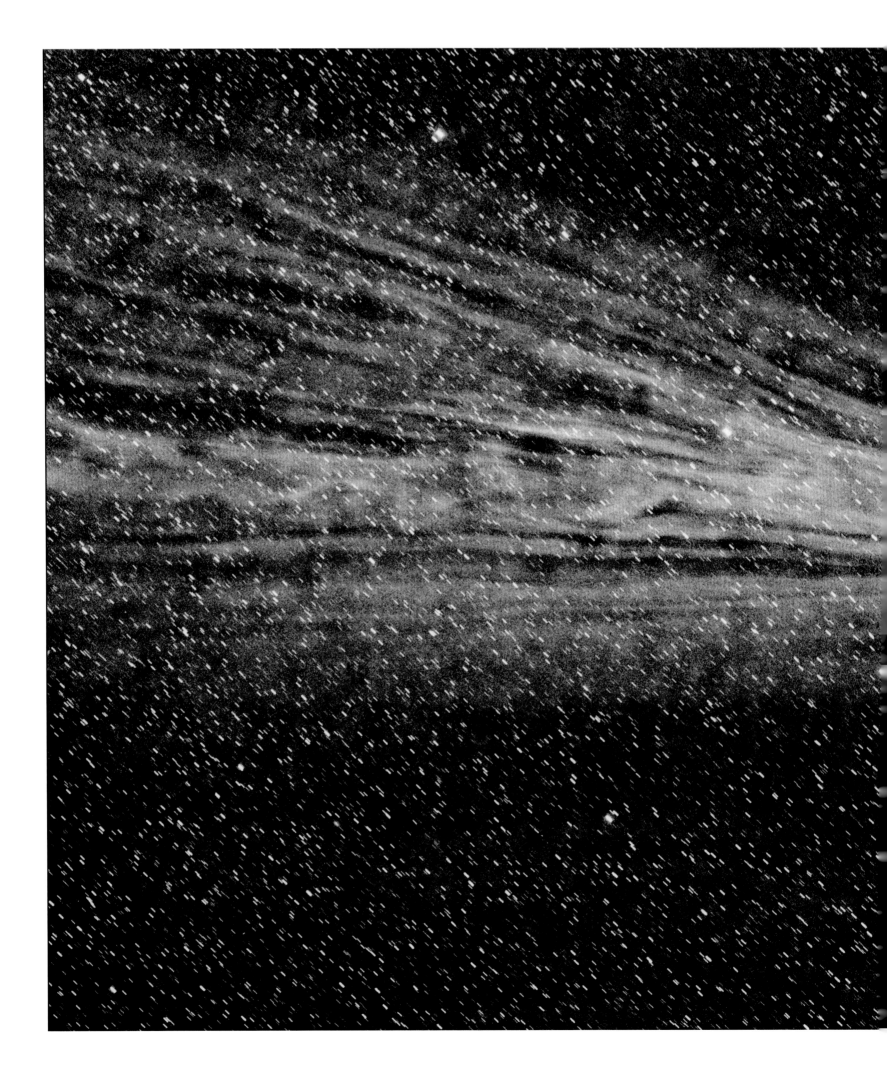

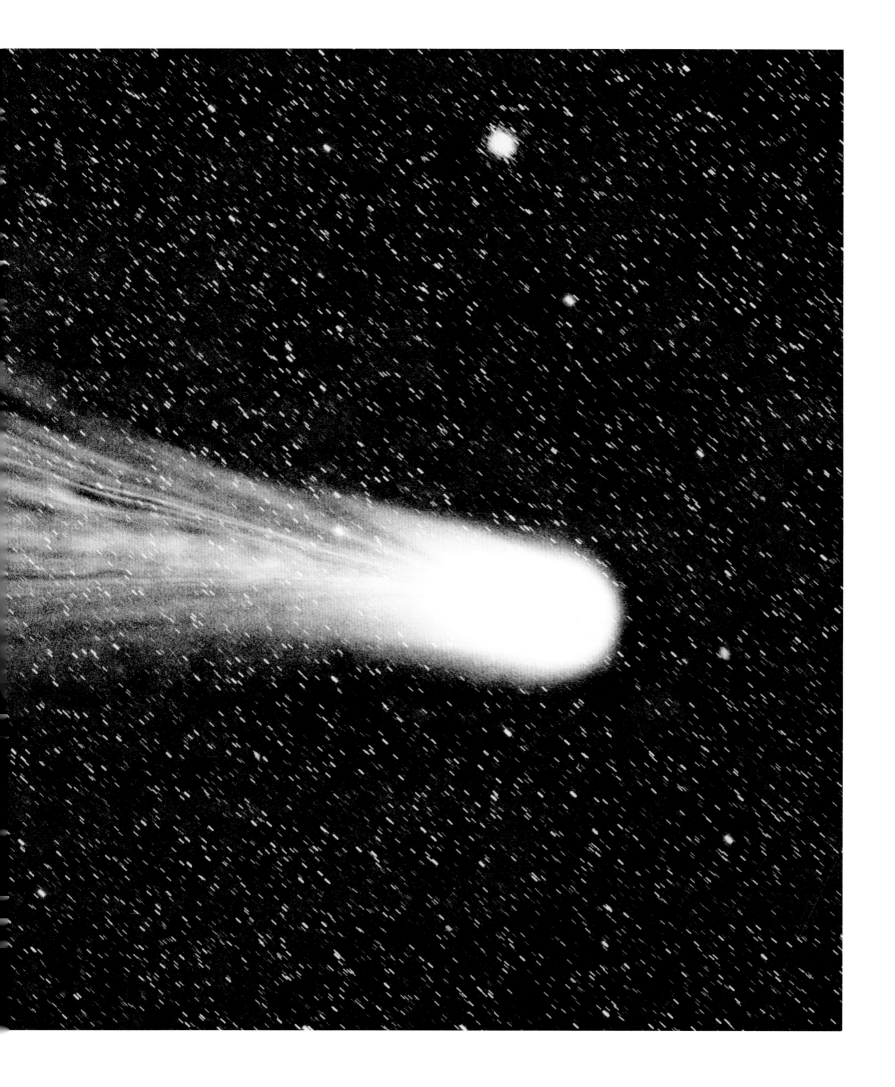

Comet Hyakutake,
18-19 March 1996
>
Quite by chance, two remarkable comets appeared in
1996. One, Hale-Bopp, seemed to be visible for many
months; the other, discovered by Yuji Hyakutake,
simply flashed by. It was discovered in January and the
week after this picture was taken it came closer to the
Earth than any other comet in the last two centuries.
For a few hours it was a spectacular sight, with a tail
almost 40 degrees long, covering almost a quarter of the
sky. In this photograph we see a 'disconnection event'
in the comet's tail, which is affected by irregularities
in the solar wind. It will be 100,000 years before this
comet appears again. The narrow white line is sunlight
reflected from an earth-orbiting satellite.

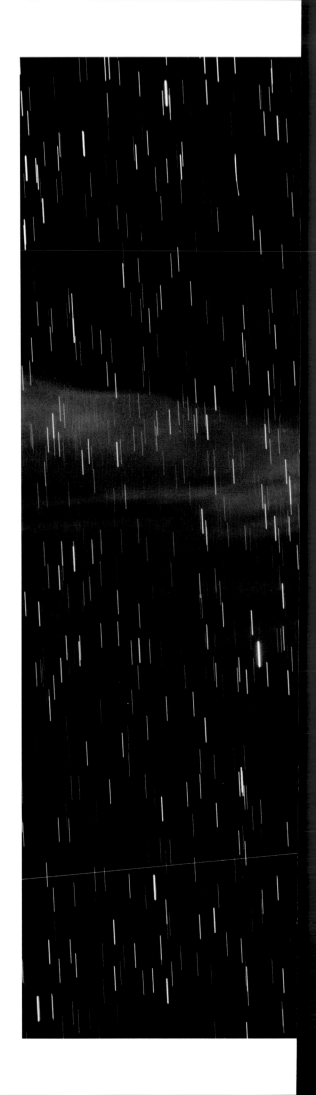

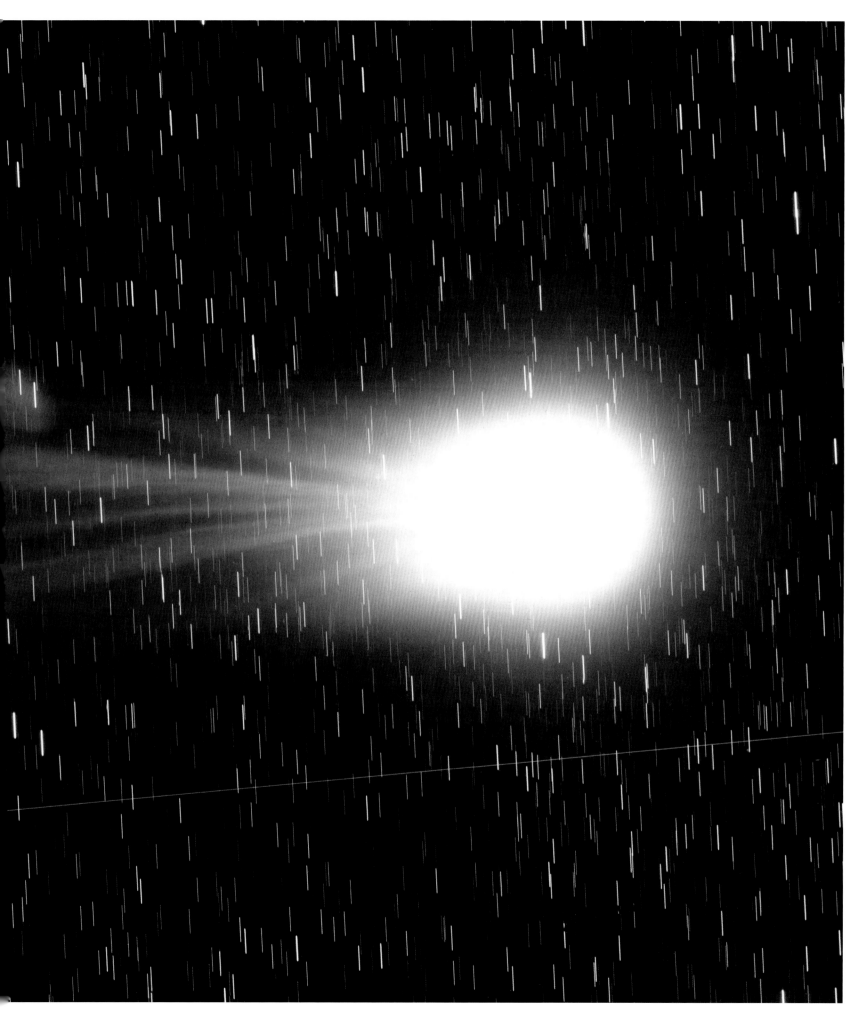

>

Unseen by northern hemisphere eyes, the South Celestial Pole has no bright star to guide the navigator and few distinctive constellations to attract the stargazer's eye. However, Canopus, the second brightest star in the night sky, is in this wide-angle photograph, as is Achernar, marking the southern end of the enormous constellation of Eridanus, the celestial river, which winds northwards from the southern sky to distant Orion on the celestial equator. Because of its southerly declination, much of this part of the sky was unknown to the Arabian namers of the stars and Babylonian constellation builders. Thus most of the constellations here are relatively modern constructions, several named by the Abbé Nicolas de Lacaille during his sojourn in South Africa in the 1750s. These undistinguished groups include Fornax (the chemical furnace), Caelum and Sculptor (the sculptor's chisel and workshop respectively), Pictor (the painter's easel), Microscopium and Horologium (the microscope and the clock) and Octans (the octant, a forerunner of the sextant). Since there is no Milky Way in this part of the sky to mask more distant things, most of the objects in this section are galaxies in Sculptor and Fornax and include one of the southern hemisphere's most spectacular jewels, the globular cluster 47 Tucanae. The image opposite also shows the nearest galaxies to the Milky Way: the Large and Small Magellanic Clouds (SMC), named after an early explorer of the southern seas, Ferdinand Magellan.

Fornax, Sculptor and the South Celestial Pole

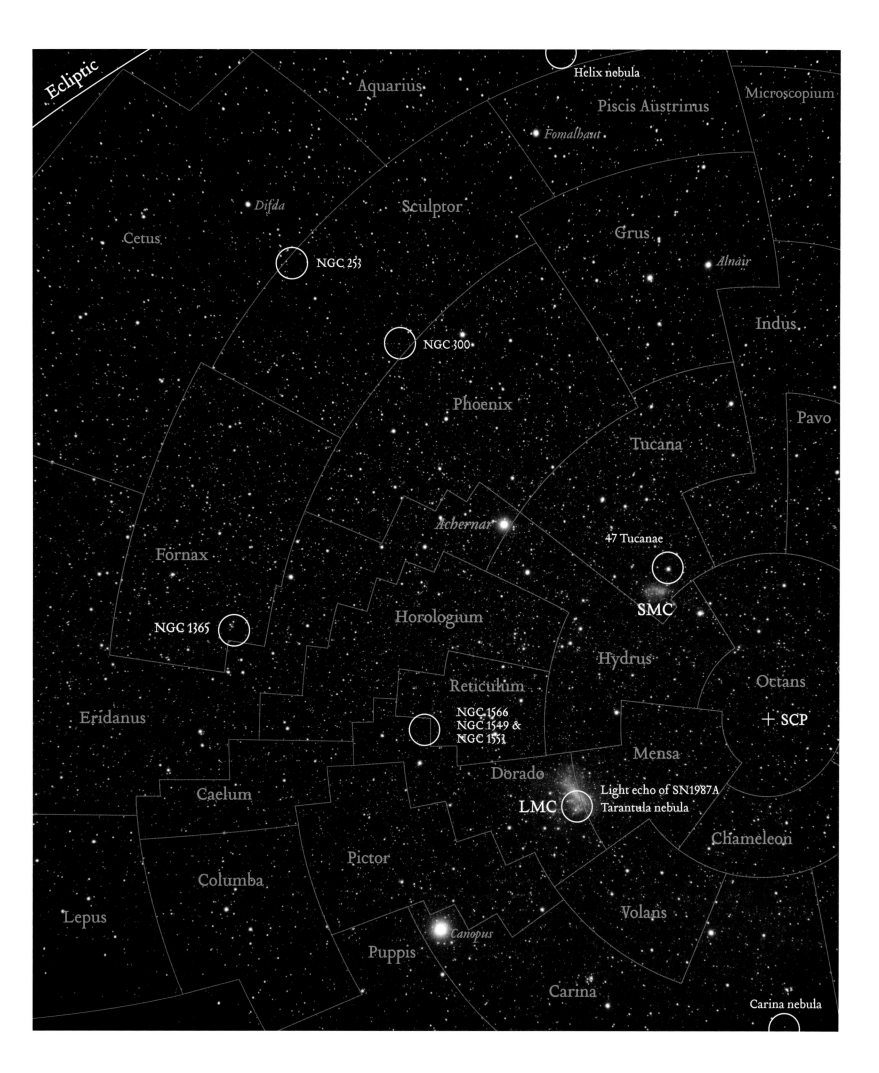

Ecliptic

Aquarius

Helix nebula

Piscis Austrinus

Microscopium

Fomalhaut

Sculptor

Grus

Difda

Alnair

Cetus

NGC 253

Indus

NGC 300

Phoenix

Pavo

Tucana

Fornax

Achernar

47 Tucanae

Octans

NGC 1365

Horologium

SMC

Hydrus

Eridanus

Reticulum

NGC 1566
NGC 1549 &
NGC 1553

+ SCP

Mensa

Caelum

Dorado

Light echo of SN1987A
Tarantula nebula

LMC

Chameleon

Pictor

Columba

Volans

Lepus

Canopus

Puppis

Carina

Carina nebula

The compact nucleus of 47 Tucanae in Tucana
<

The southern sky is well endowed with astronomical
splendours, but none as magnificent as the globular
cluster 47 Tucanae. The most distinctive feature of
47 Tucanae is its tiny, bright nucleus, emphasized here.
The stars in the nucleus are quite close together in
space and interactions between them are relatively
common. For an ancient collection of stars the variety
here is remarkable, with many unusually blue stars,
short period pulsars, the tiny, spinning remnants of
long-dead stars, and related energetic X-ray sources,
none of which are common in globular clusters. It is
possible that 47 Tucanae is the remains of the compact
nucleus of a galaxy that has ventured too close to the
Milky Way and been disrupted by it.

47 Tucanae, widefield, in Tucana
>

Easily seen with the unaided eye as a fuzzy patch
alongside the Small Magellanic Cloud, globular cluster
47 Tucanae resolves into thousands of faint stars in a
small telescope. In a large telescope and on deep
photographs, 47 Tucanae extends over half a degree of
sky, about the same apparent size as the full Moon, and it
contains at least a million stars. Observing it in the 1830s,
John Herschel called it 'a stupendous object' and noted
that 'it is compressed to a blaze of light at the centre…'

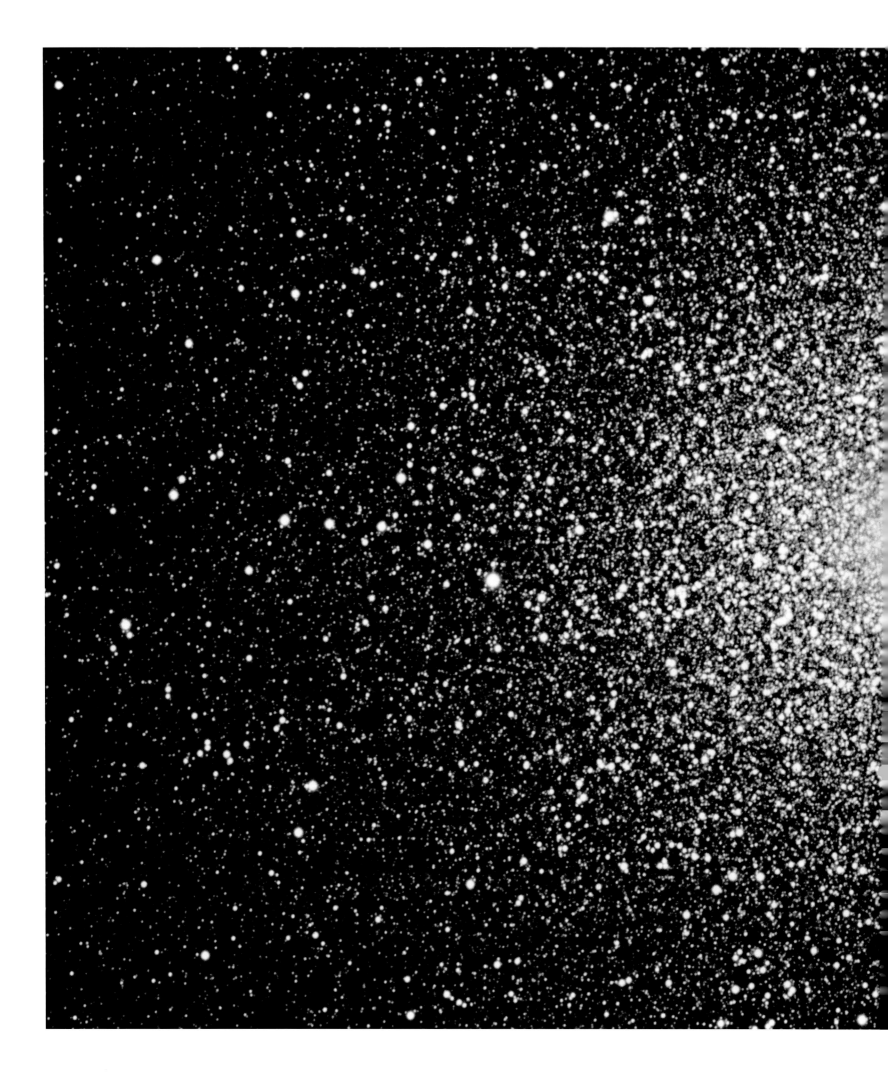

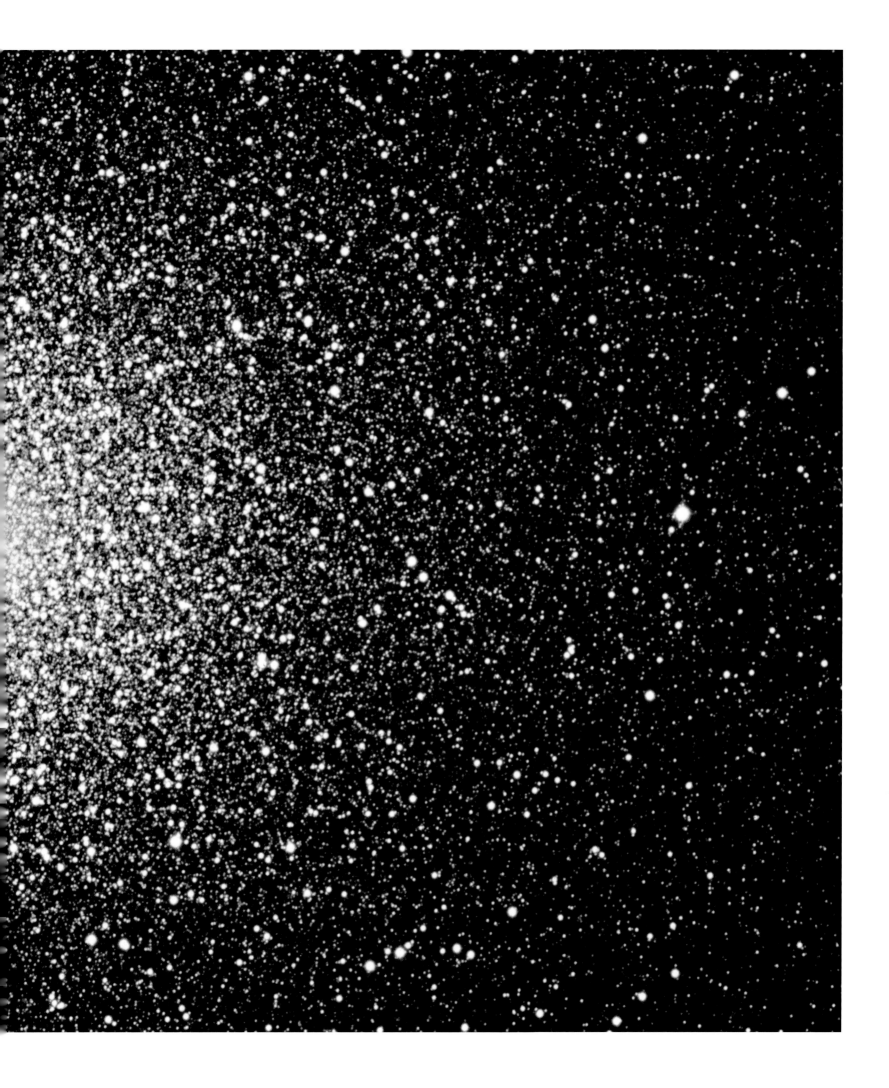

NGC 1365, a barred
spiral galaxy in Fornax

>

Symmetrical structures in nature always catch the eye
and imply a sense of order or design. Often, as here,
the symmetry is not perfect, which suggests that the
design was hasty or that the order is more concerned
with general principles than fine details. In truth, it is
not completely understood why this particular galaxy
and the many others like it have two gracefully curved
arms with a dusty central bridge between them. This is
just one of the reasons that people study spiral galaxies;
in the same way, other kinds of scientists wonder about
the patterns in sunflowers and cyclones.

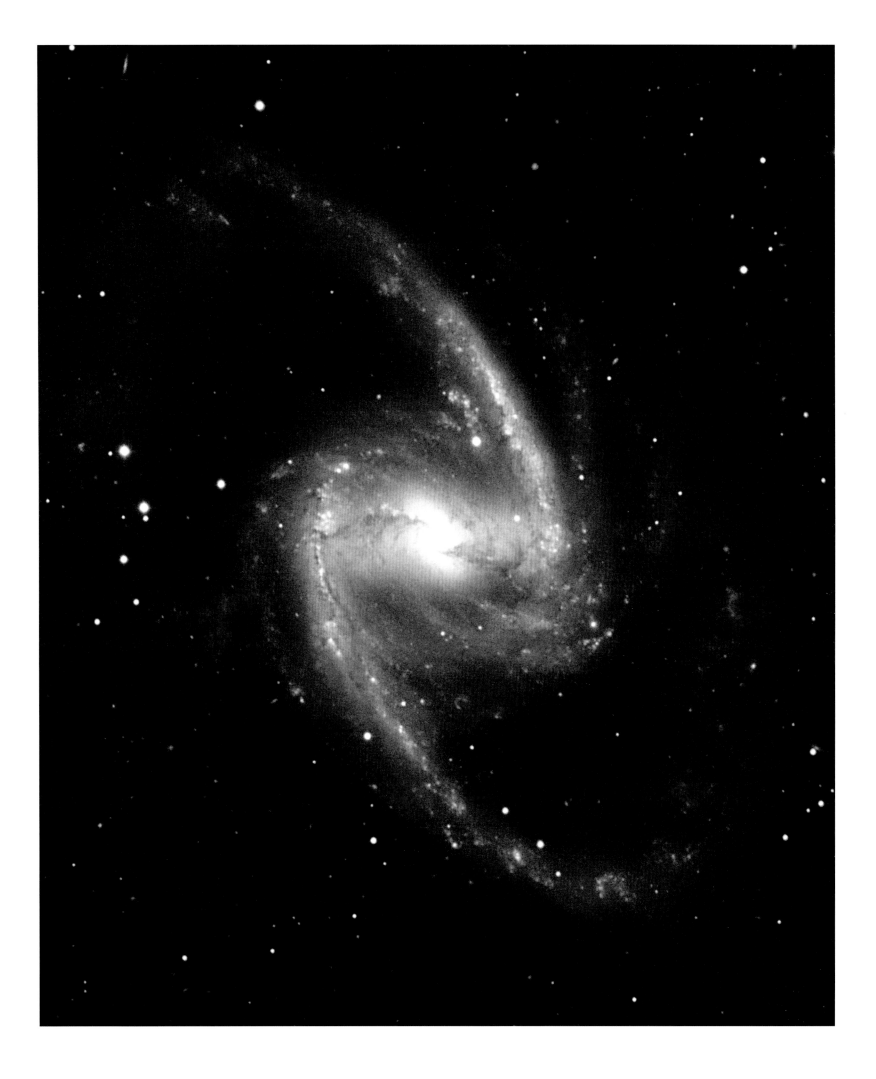

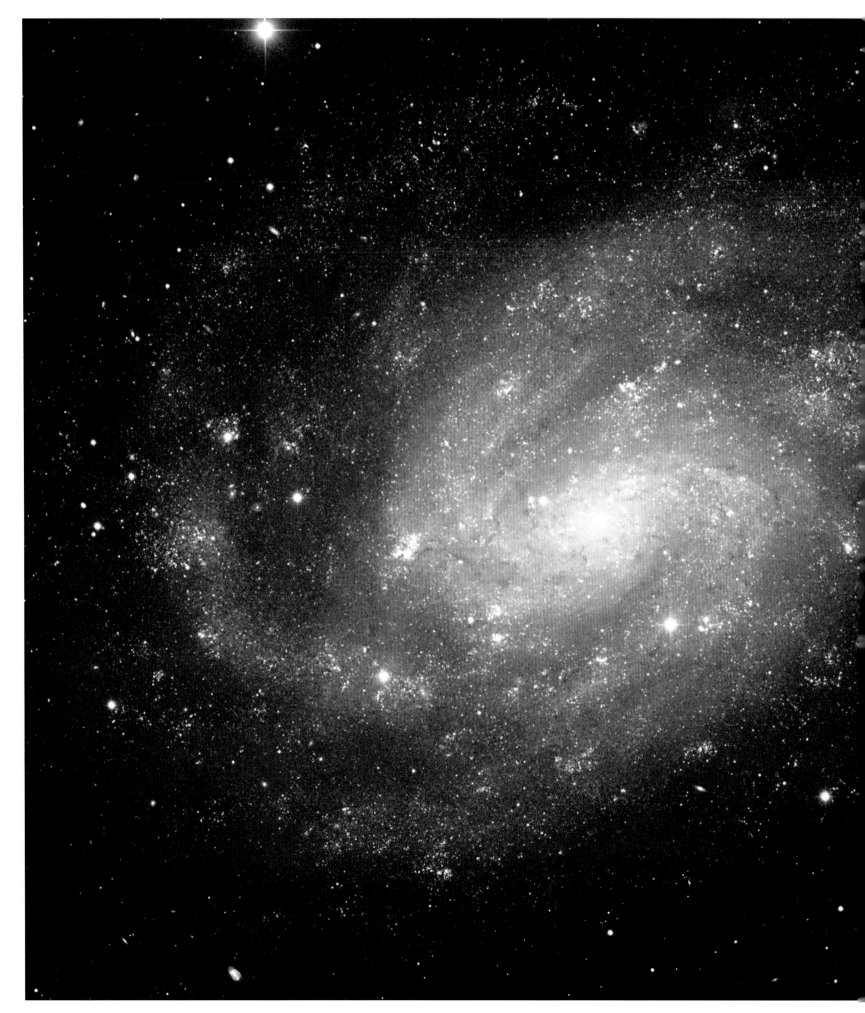

NGC 300, a galaxy in Sculptor

<

Galaxies are vast collections of stars, scattered across
the sky in infinite variety. The larger examples consist of
thousands of billions of stars and some of the faintest
contain a million, so NGC 300, which contains a few
billion, lies somewhere in-between. Most galaxies are
too far away for their stars to be seen as individuals,
but as NGC 300 is only about seven million light years
distant, the brightest stars in this galaxy are visible in
this photograph. NGC 300 is one of the closer members
of a small group of spiral and irregular galaxies that are
scattered across the southern constellation of Sculptor.

NGC 253, a galaxy in Sculptor

>

NGC 253 was discovered by Caroline Herschel, sister of
the famous astronomer William, in 1783, and is a dusty,
almost edge-on spiral galaxy about ten million light
years distant in the southern constellation of Sculptor.
The dust is seen as clumpy dark clouds in the part of
the galaxy that is closest to us, while the rest of this
star-rich spiral is relatively unobscured, with very few
foreground stars to complicate the picture. Though five
times more distant than the Andromeda galaxy,
NGC 253 is close enough for us to see its structure in
great detail. The fluffy bright clouds are huge numbers
of unresolved stars that make up the spiral arms of the
galaxy, which would be seen as a fairly smooth disk
with a spiral structure superimposed if it was not for
numerous dust clouds. These are also embedded in the
spiral arms, absorbing the starlight behind them, an
effect we see in our own galaxy, the Milky Way.
Many of these have spawned young stars and these
are bright enough to be seen as individuals. In the
background are many other galaxies like NGC 253,
each as rich in stars and dust. NGC 253 lies at the south
galactic pole, so while we see it highly inclined on the
sky, any inhabitants of NGC 253 would gaze on the
Milky Way as a spectacular face-on spiral, much as we
see M83 [see p 096–097].

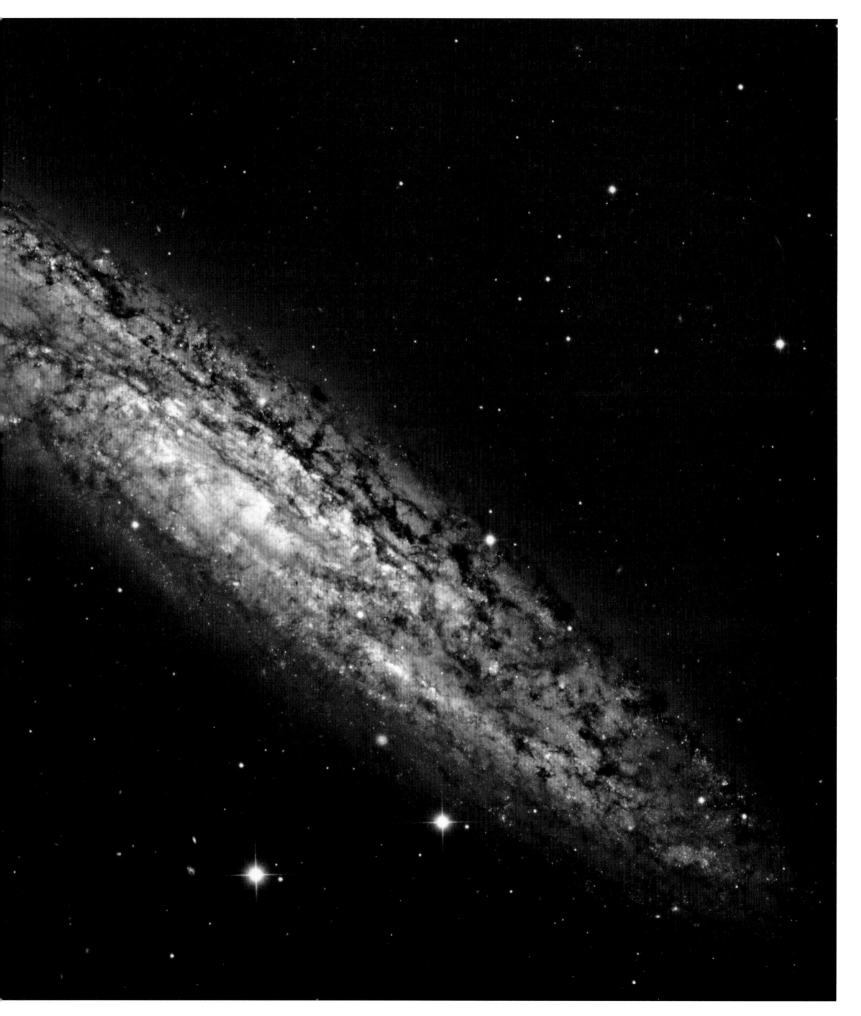

The Helix nebula in Aquarius

>

Stars are born, live their lives and finally die. The
longevity of a star and the manner of its demise are
largely determined by its mass at birth. Massive stars
live relatively short lives that end in a spectacular
supernova explosion. Less massive, Sun-like stars
have much longer lives that end when the star throws
off its outer layers, exposing its hot inner core. As
the star's outer layers expand into space they usually
form hollow, symmetrical structures whose shapes are
widely variable, and whose appearance depends on its
orientation on the sky. These quite common clouds of
luminous gas are known as a planetary nebulae, like
the Helix, named for its coil-like structure, which is an
hour-glass shape seen almost end-on. At its centre lies
the glowing remains of the burned-out star.

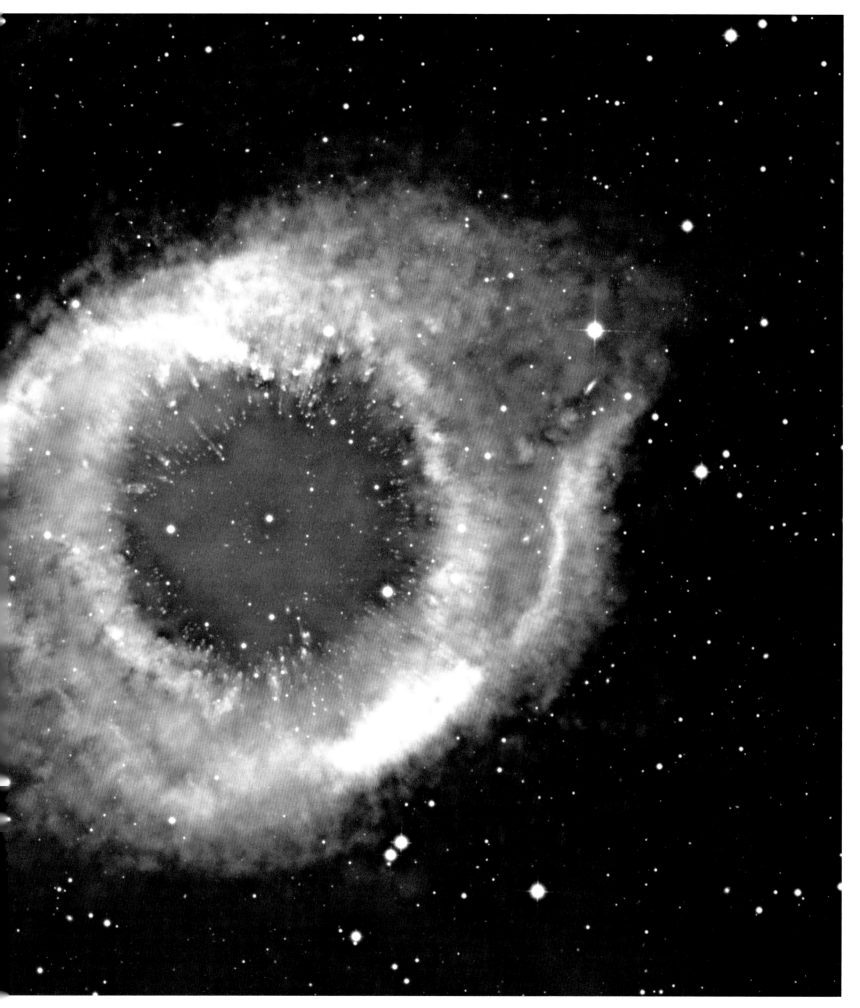

>

Reticulum (originally Reticulum Rhomboidalis) is another of Nicolas de La Caille's faint southern hemisphere constellations, first described in the 1750s. The name refers to the net-like crosshairs used in a telescope eyepiece to measure object positions. Dorado (the Goldfish or Swordfish) is usually attributed to the Dutch navigators Pieter Dirkszoon Keyser and Frederick de Houtman, who defined twelve new constellations during their voyages to the East Indies — the modern Malaysian Archipelago and Indonesia — between 1595 and 1597. The German astronomer Johann Bayer introduced the new constellations in his acclaimed *Uranometria* star atlas in 1603. Neither constellation is particularly noticeable, however, and this would be a mostly unremarkable part of the night sky without the Large Magellanic Cloud (LMC). About 170,000 light years distant, this is the closest galaxy to our own, and to the unaided eye appears as a detached part of the Milky Way. Under a clear, dark sky the elongated 'bar' of the galaxy is evident, and the Taranatula nebula looks to the unaided eye like the Orion nebula, which is one hundred times closer to us. Several of the telescopic images in this section reveal striking details of the LMC, including the Tarantula nebula and a transient light echo from an exploding star. Elsewhere in the constellation we find two interesting and much more distant galaxies.

The Swordfish & the Large Magellanic Cloud

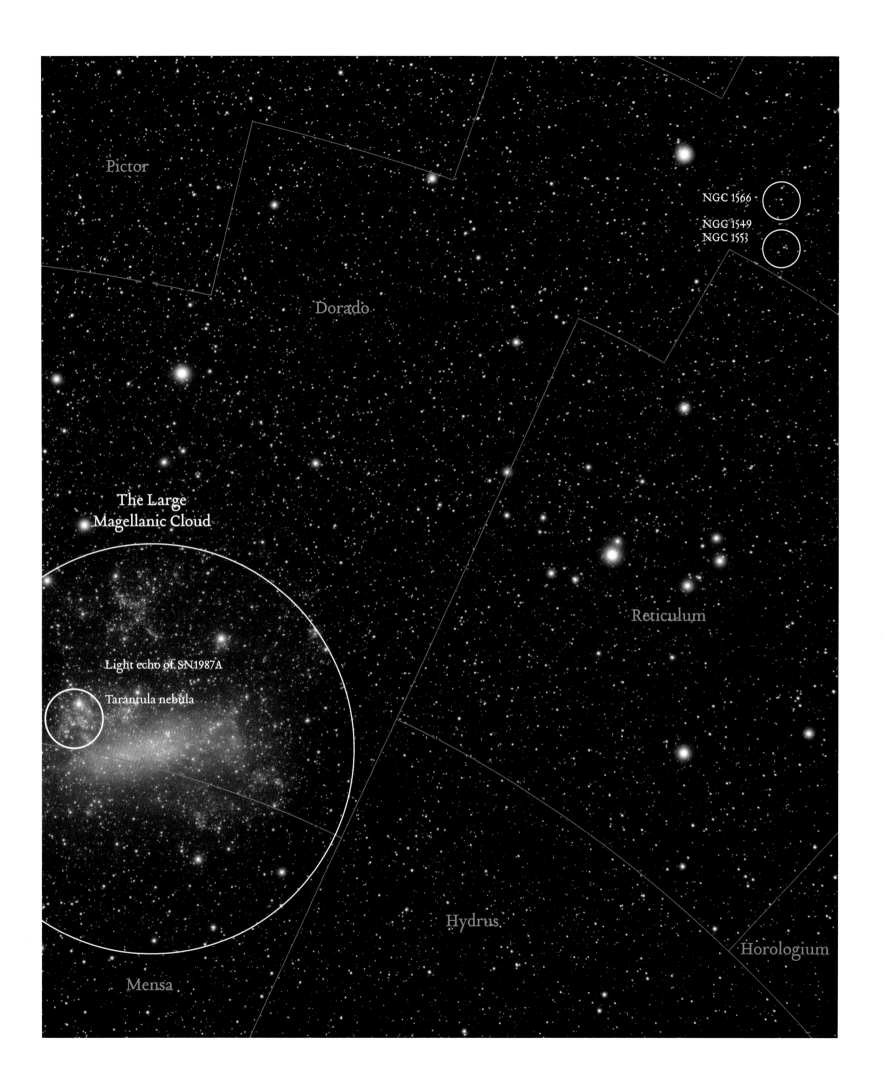

Pictor

NGC 1566

NGC 1549
NGC 1553

Dorado

The Large
Magellanic Cloud

Reticulum

Light echo of SN1987A

Tarantula nebula

Hydrus

Horologium

Mensa

NGC 1549 and NGC 1553,
a galaxy pair in Dorado

>

NGC 1549 and NGC 1553 are in the constellation
Dorado, in the southern sky, unseen from northern
latitudes. The galaxies appear featureless and are known
as 'ellipticals', the commonest kind of galaxy. Each is
composed of billions of stars, not seen as individuals on
this photograph. They are at a similar distance from us,
about 50 million light years, and are close together in
space. On very long exposures there is evidence that the
two galaxies are interacting, drawn together by their
own gravity. This displaces stars from the outskirts of
each of them to create a faint network of loops, shells
and filaments that hint at a more permanent merger in
the distant future.

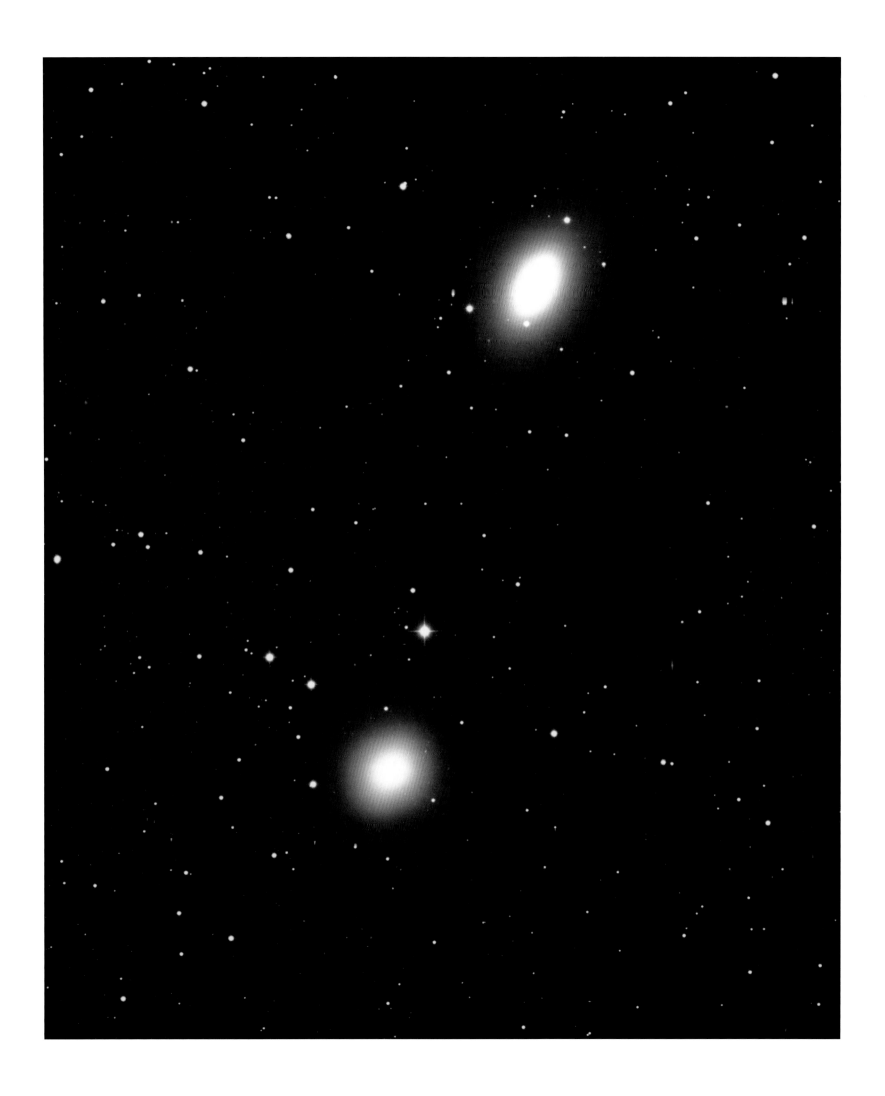

NGC 1566, a Seyfert galaxy in Dorado

>

NGC 1566 is 50 million light years away, in the
direction of the constellation of Dorado (the Goldfish
or Swordfish) in the far southern sky. It is a small spiral
galaxy with an unusually bright nucleus and equally
unusual faint spiral arms, which appear somewhat
detached from the more conspicuous brighter inner
arms. Analysis of light from the nucleus reveals
features that suggest it is 'active', probably due to the
presence of a massive Black Hole, which accelerates
matter to high velocities and very high temperatures.
The radiation from the nucleus is also variable on short
time-scales. Such a spectral signature was first noted by
Carl Seyfert 50 years ago, and often signifies a galaxy
that has undergone some kind of interaction, which
would also explain the displaced spiral arms. However,
there is no sign of a companion galaxy.

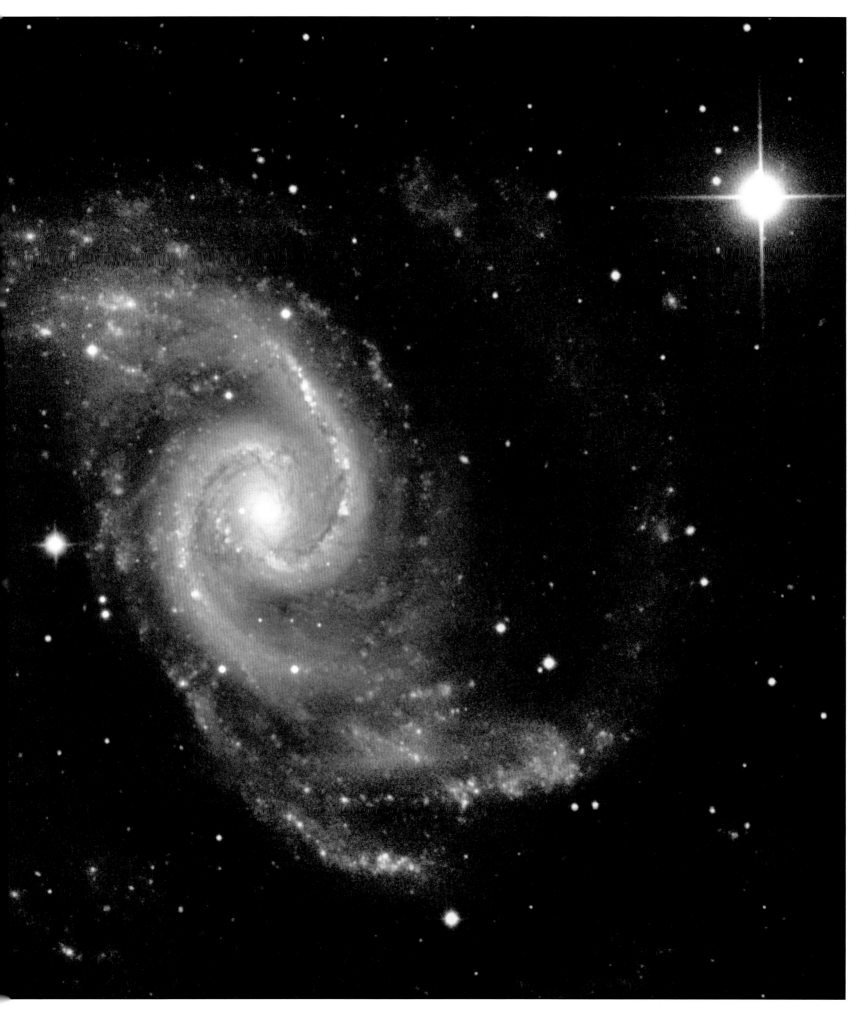

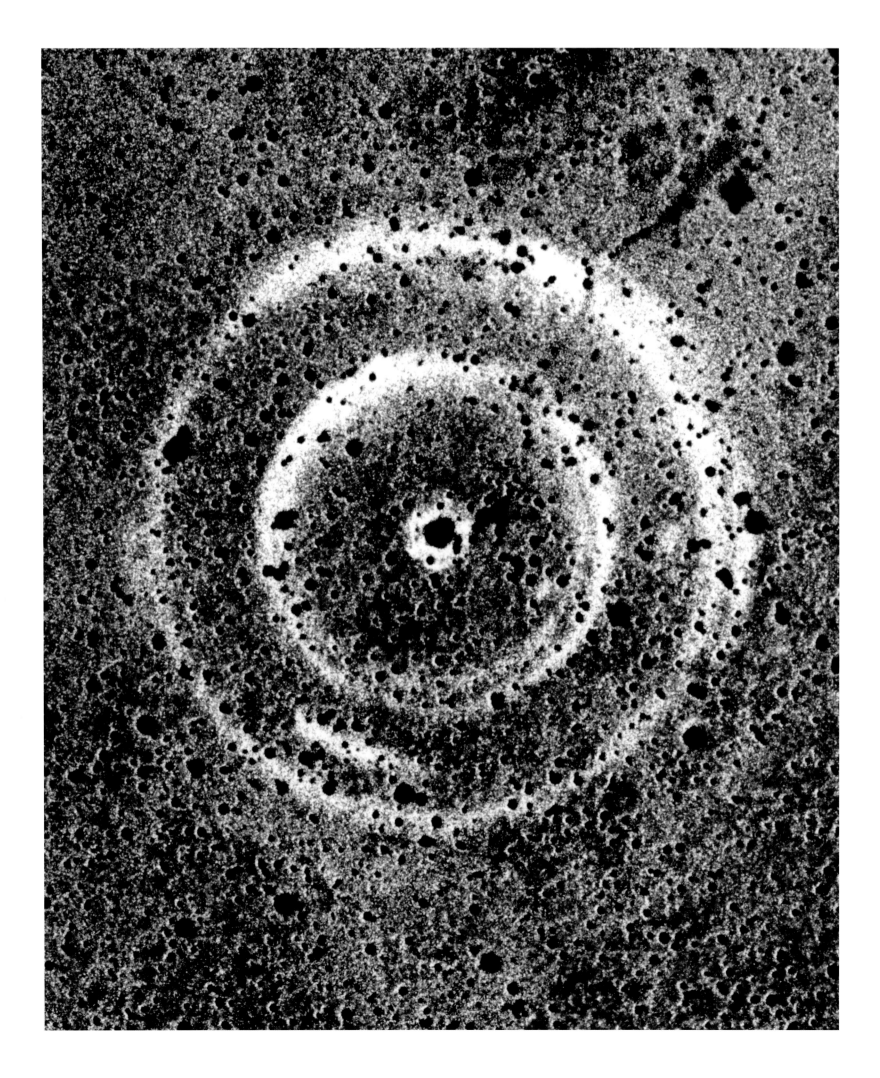

The light echo of supernova 1987A
in the Large Magellanic Cloud, in Dorado

<

An unstable star suddenly explodes in a nearby
galaxy and a pulse of light travels through space in
all directions. Long after the supernova has faded to
invisibility, the expanding sphere of light is scattered
by two sheets and fragments of dust near the supernova
and close to our line of sight. The scattered light travels
a longer path than did the supernova's light and arrives
years later, an echo in the form of faint concentric
circles, ripples of light through dust scattered among
the stars. They have been revealed here by combining
pre- and post-supernova photographs, the main
difference between them being the rings of light,
centred on the now-faded star.

Around the Tarantula nebula in the
Large Magellanic Cloud in Dorado
>

This astonishing scene surrounds the Tarantula, a
bright nebula that is one of the most intense regions of
star formation known anywhere. The Tarantula nebula
is 170,000 light years away in the Large Magellanic
Cloud, the nearest galaxy to the Milky Way. The nebula
itself is visible to the unaided eye from dark, southern
hemisphere skies, and in a modest telescope it appears
as a diffuse, starry body from which spindly streaks
of light emerge, hence its popular name. This picture
covers a region of the Large Magellanic Cloud about
2,000 light years across, so if the Sun and its retinue of
planets were suddenly transported to the edge of this
scene, the Tarantula nebula would span almost half the
sky and the night would be filled with brilliant stars,
since most of those seen in this photograph are millions
of times more luminous than the Sun.

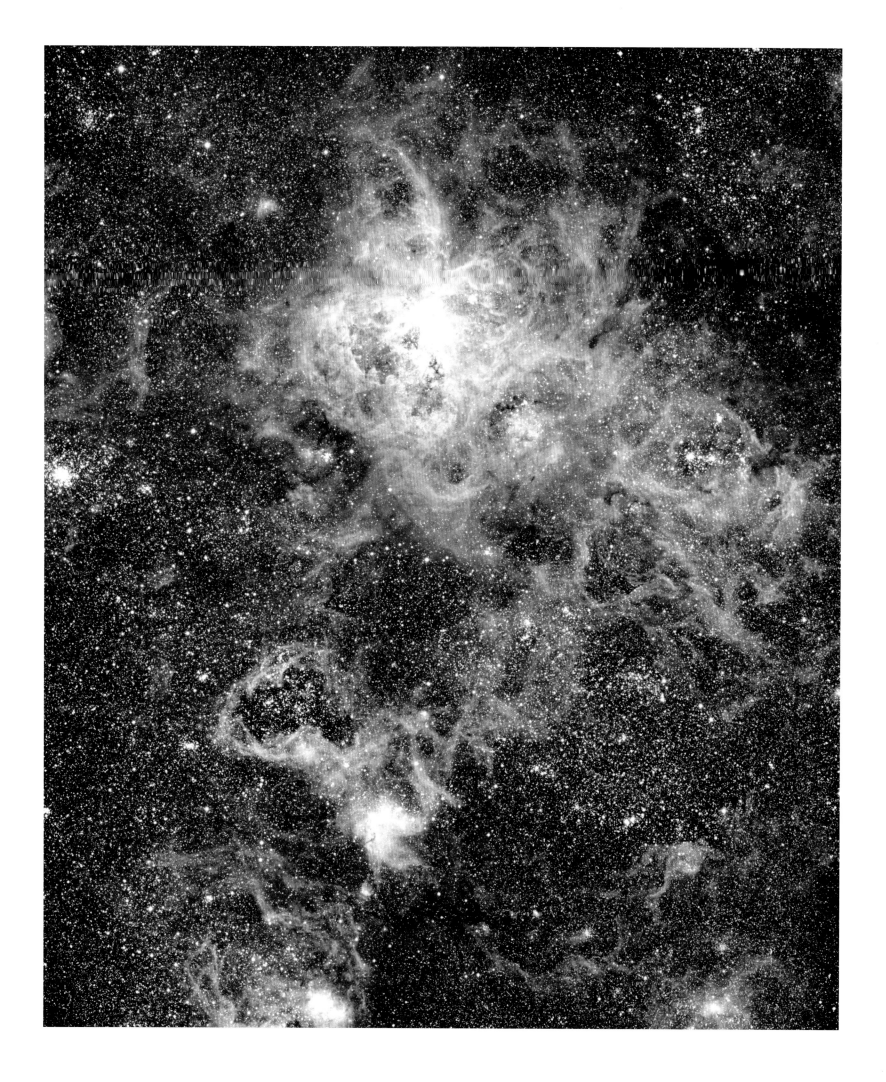

The names, ancient figures and exotic creatures embodied in the zodiacal constellations can be traced back to the dawn of western civilization, the patterns in the stars tracing out the lore and legends of the ancient world. Sagittarius (the Archer), Ophiuchus (the Serpent Holder) and Scorpius (the Scorpion) are three of the 48 constellations listed in Ptolemy's *Almagest* in about AD 140, almost all of which are incorporated into the modern constellation outlines. The constellations are defined by the brightest stars, but in this part of the sky also lies the most conspicuous stretch of the Milky Way, a flattened disc of billions of faint stars that we see from the inside. Somewhere close to the middle of the image opposite lies the centre of our Galaxy, which is completely obscured by clouds of foreground dust. It is from this dust that new stars are born and all the objects in this section are star-forming regions. Running across the picture is the Ecliptic, the path followed by the Sun and, within a degree or two, the planets across the sky. When this photograph was taken, in April 2001, Mars was prominent in the Milky Way, matching itself against its starry rival Antares, which has a similar ruddy colour. Between November and January, the Sun is in this part of the sky, so the Milky Way is visible between May and September, and best seen from the southern hemisphere, where it is overhead during the nights of winter.

Along the Galactic Equator

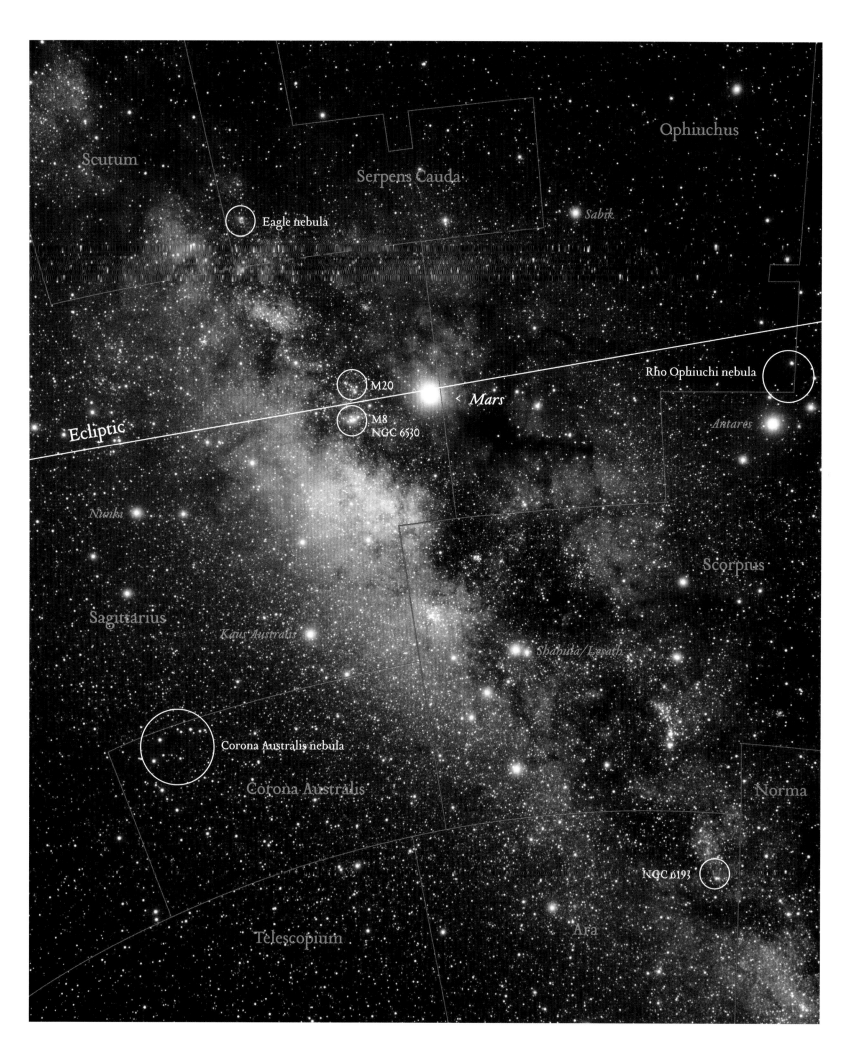

Scutum

Ophiuchus

Serpens Cauda

Sabik

Eagle nebula

Rho Ophiuchi nebula

M20

< *Mars*

Ecliptic

M8
NGC 6530

Antares

Nunki

Scorpius

Sagittarius

Kaus Australis

Shaula/Lesath

Corona Australis nebula

Corona Australis

Norma

NGC 6193

Ara

Telescopium

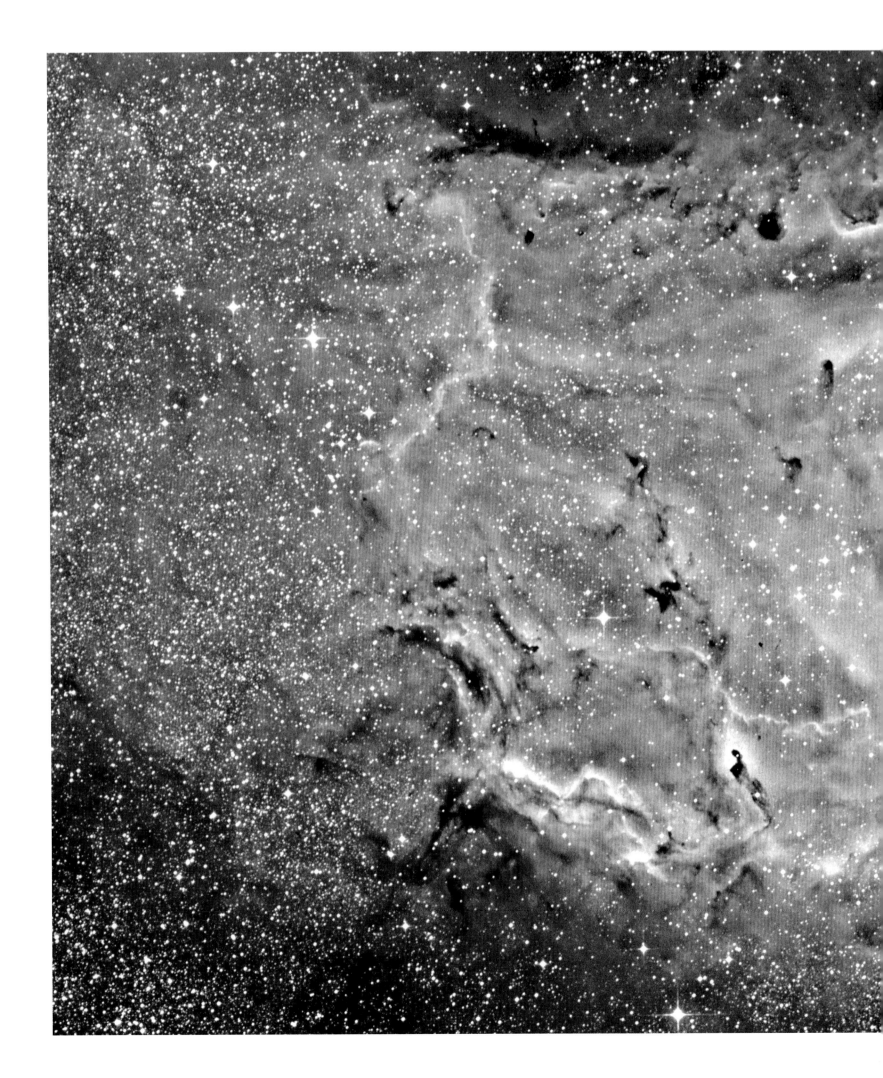

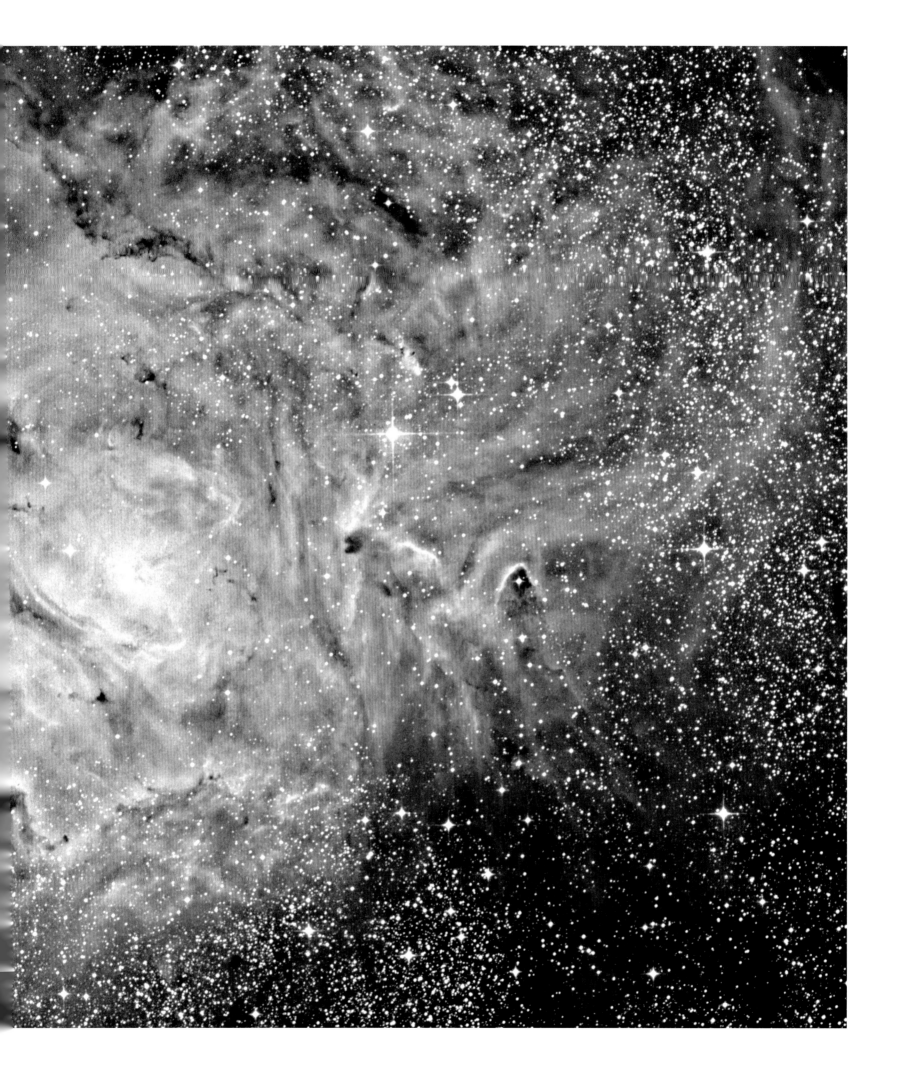

M8, the Lagoon nebula
in Sagittarius

<

Superimposed on the rich star-fields of Sagittarius are
enormous dusty clouds, their dark presence obscuring
the myriads of faint stars beyond. Within these dark
clouds, stars form and light up their surroundings,
creating highly structured glowing patches of light
known as nebulae. The Lagoon nebula has been known
for over 350 years and is about 5,000 light years away,
clearly visible to the unaided eye. Among its most
distinctive features are the small, dark globules of dust,
and a broad sinuous dust lane (the dark lagoon) seen in
silhouette against the nebula, which give this object its
popular name. This feature is best seen on the shorter
exposure opposite.

The Hourglass nebula and open cluster
NGC 6530 in Sagittarius

>

The Frenchman Charles Messier (1730–1817) was a
prolific discoverer of comets. In the telescope the fuzzy
shape of these occasional mobile visitors can easily
be confused with nebulae, galaxies and faint clusters
of stars that are permanent features. To avoid this
distraction, Messier compiled a list of over 100 of the
brightest 'fixed' nebulae, a catalogue that is still in use
today. M8 was added in May 1764 and described as 'a
cluster which appears in the shape of a nebula when
observed with an ordinary telescope'. The cluster
(NGC 6530) is the group of bright stars on the left of
the picture. Messier did not comment on the dark lane
across the brightest part of the nebula which gives it
its popular name, the Lagoon, but mentioned what is
now known as the Hourglass nebula (at the right of
the photograph) as 'a fairly bright star, surrounded by
a very faint glow'.

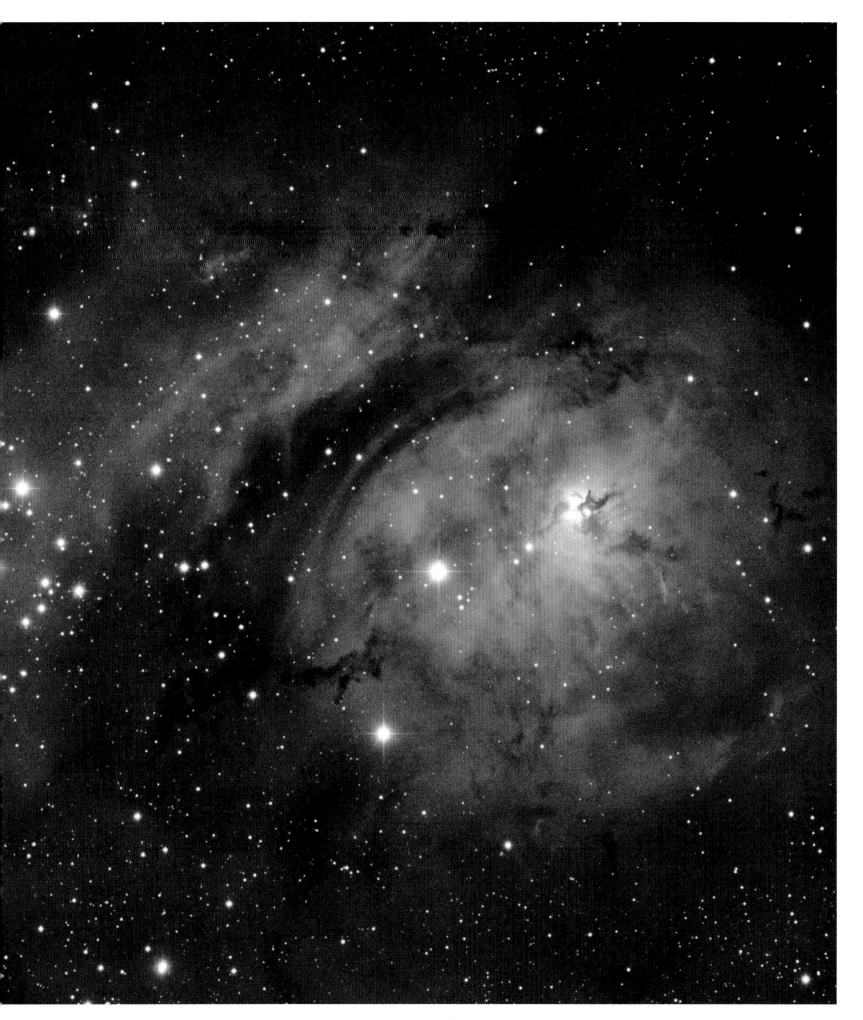

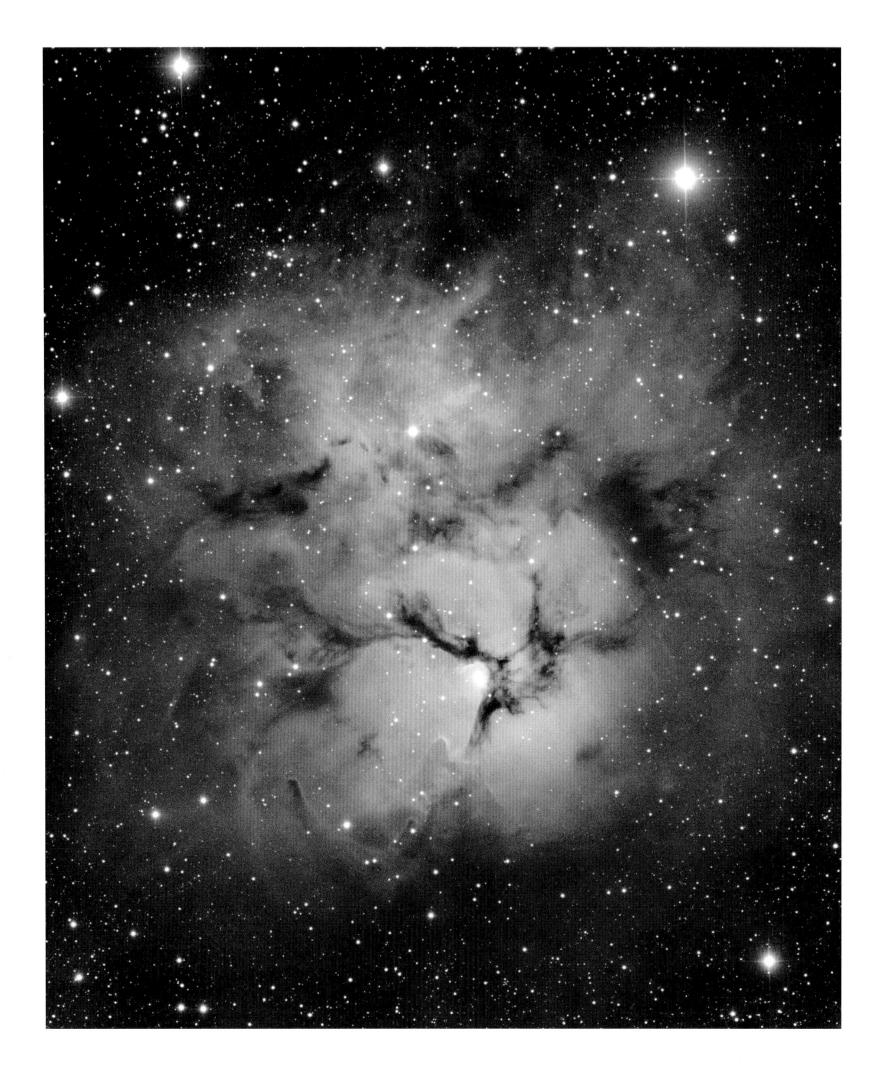

M20, the Trifid nebula in Sagittarius

<

In 1784 the great observer William Herschel said
of this scene, 'Three nebulae, faintly joined, form
a triangle.' Observing it 50 years later his son, John
Herschel, called it the Trifid nebula, hence the popular
name for this intriguing object, which is about 6,000
light years distant in Sagittarius. He described it as
'One of the most remarkable nebulae...It is very large
and has many outlying portions and sinuses.' This
complexity is clearly evident in this photograph and
the difficulty in drawing it, as Herschel did, can be
imagined. Photography allows us to see it framed
within a group of bright stars, with a delicate, flower-
like beauty that extends across a rich star-field in
Sagittarius. This is one occasion where one might
regret a lack of colour; the nebula has a red heart
surrounded by a bluish halo. The compact cluster of
stars in the brightest part of this nebula have recently
formed from the dust that still surrounds them.
Energy and light from these hot stars are together
responsible for the nebulosity that fills the field and
reveals the presence of the dust as dark markings,
where the light cannot penetrate.

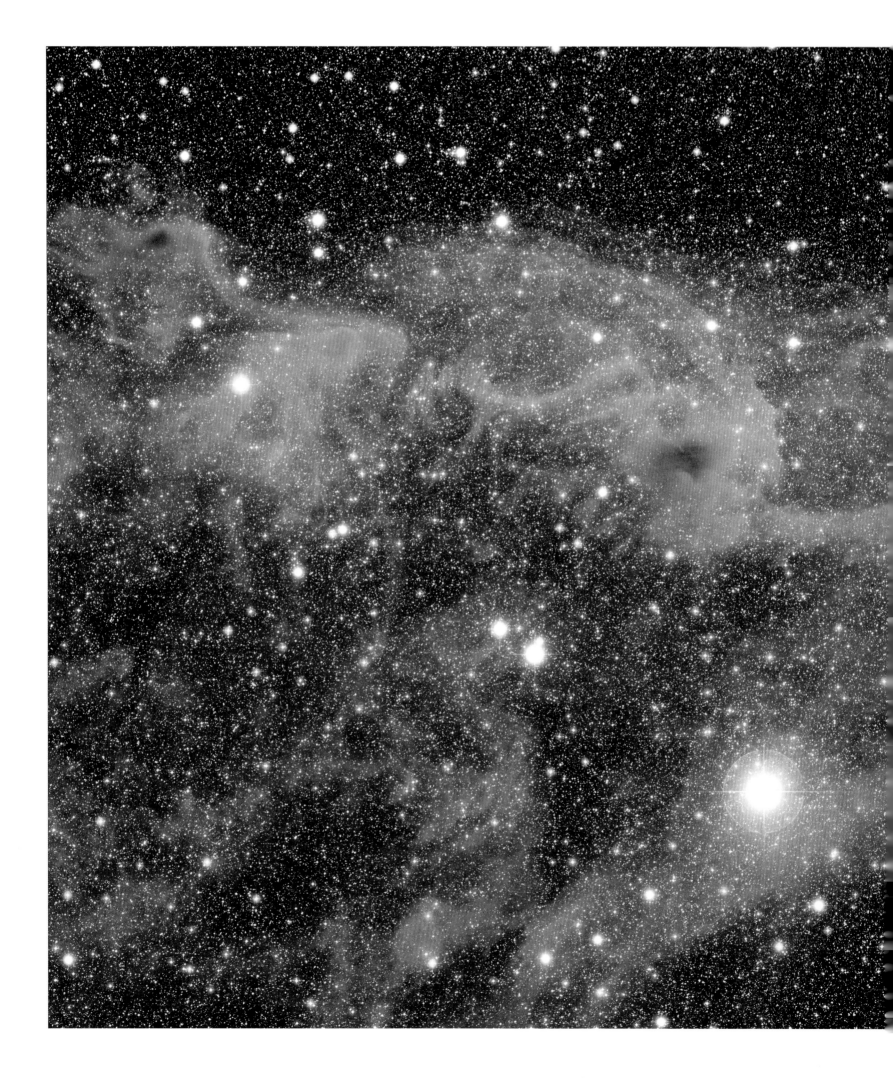

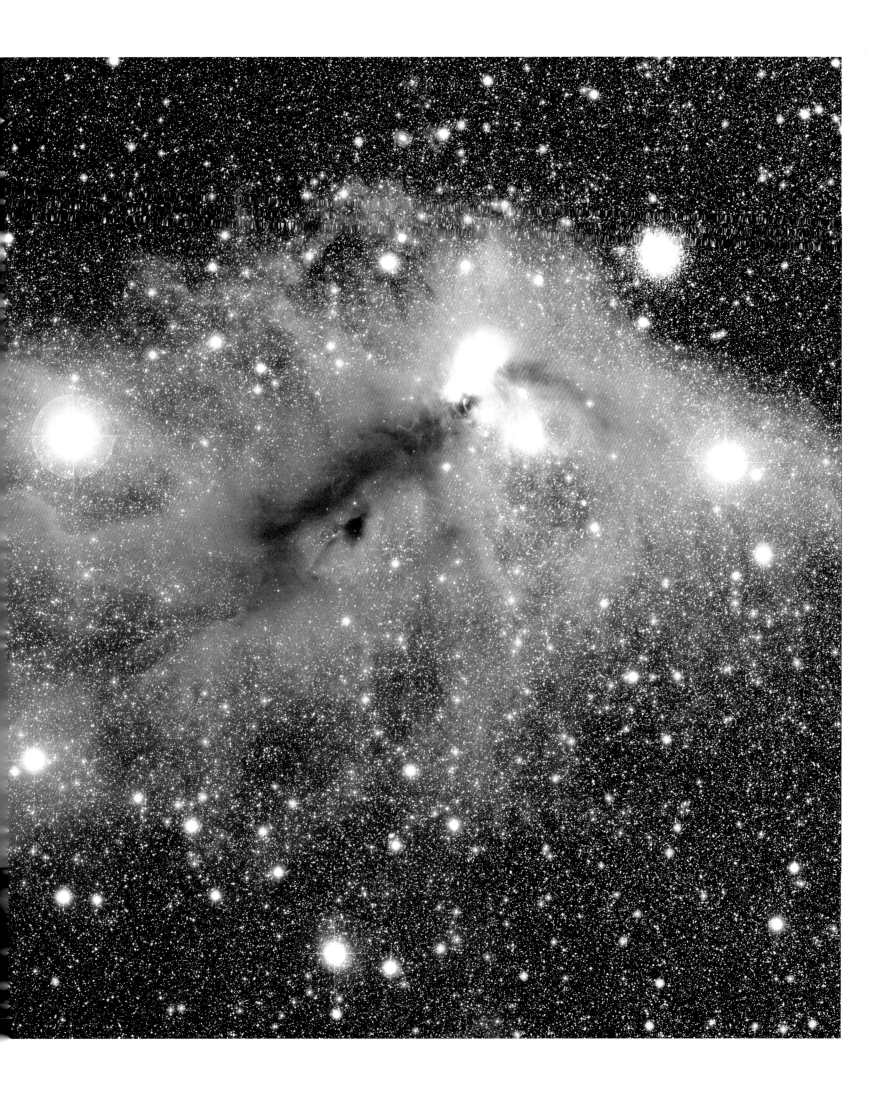

The Corona Australis
reflection nebula

<

Along the borders between Sagittarius and Corona
Australis drifts an extended cloud of dust, feebly
reflecting the light from stars within and around it.
Most of the dust is so tenuous that it hardly affects the
visibility of the numerous stars in the background,
but here and there the cloud is much more opaque,
especially at its western end, where there is a collection
of bright stars and a globular cluster, visible in the
upper right corner of the photograph. This strange
shape is about 500 light years distant and is one of the
densest dust clouds known; its western (left) end has
already spawned new stars, which light up the dust still
surrounding them.

M16, the Eagle nebula, in Serpens

>

Now known as the Eagle nebula, this highly
structured star-forming region in Serpens is number
16 in the catalogue of diffuse night sky sights in
Messier's catalogue. The dark shapes with bright rims
at the centre of the scene are interstellar dust sculpted
into structured pillars by the energy from the cluster
of nearby bright stars at upper right. They feature in a
famous Hubble Space Telescope image of M16, where
they are described as the 'Pillars of Creation'. More
generally they are known from their appearance as
'elephant trunks' and are commonly associated with
clusters of sparkling young stars.

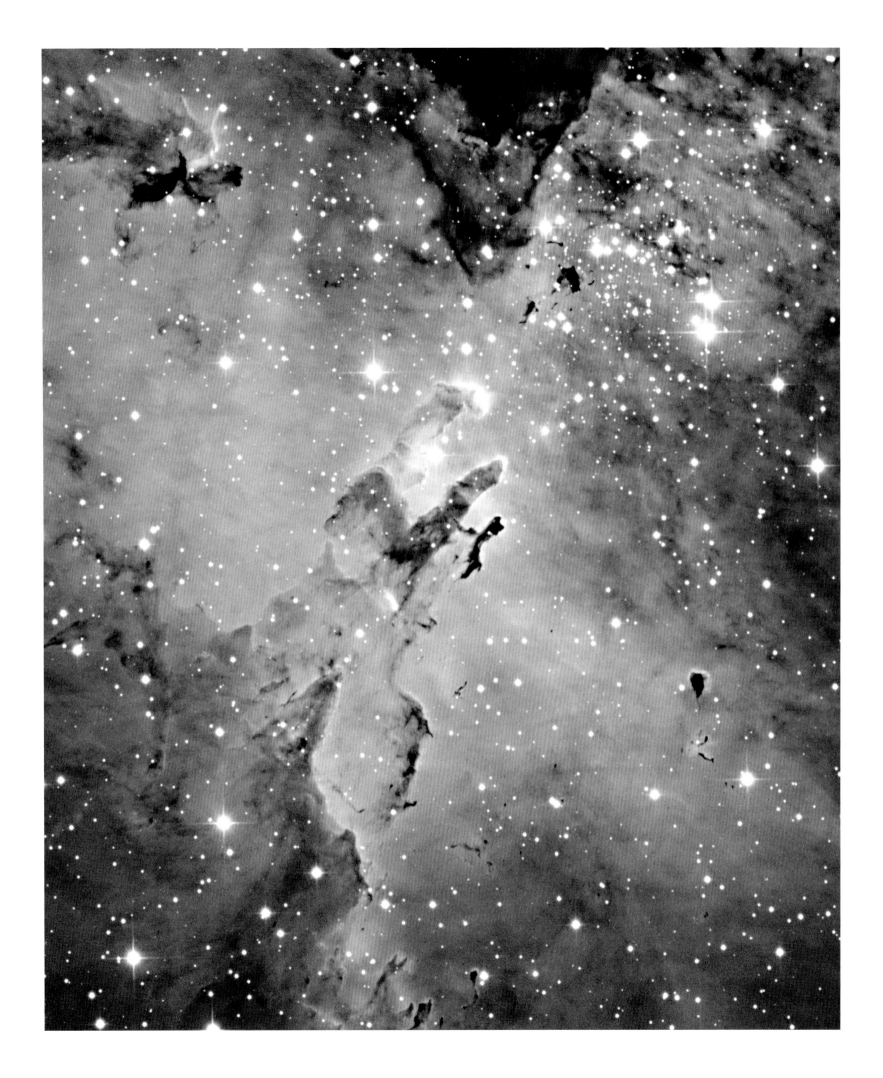

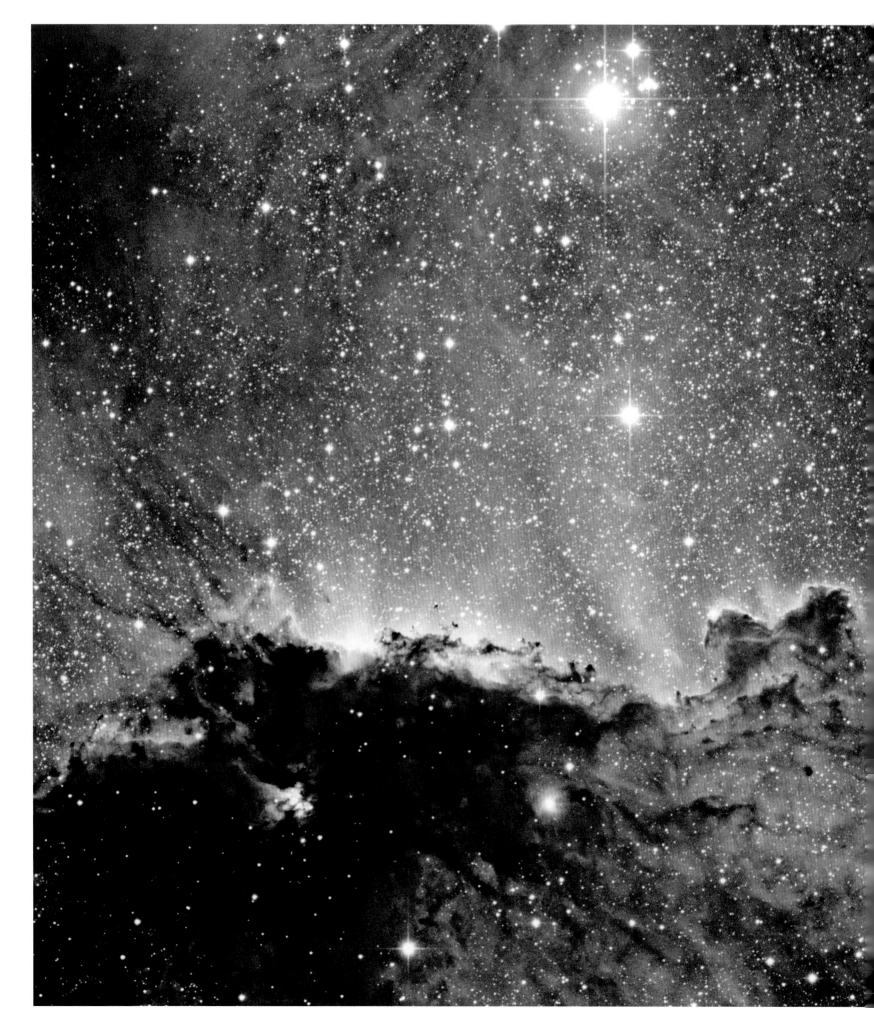

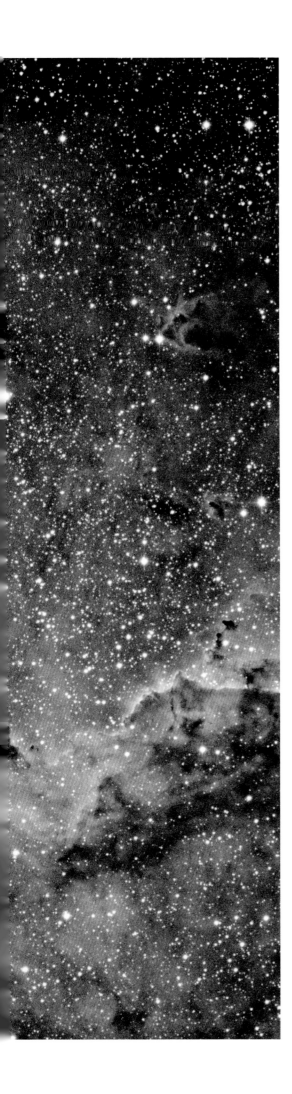

NGC 6193 in Ara

‹

Known since ancient times, Ara (the Altar) is an undistinguished constellation in the southern sky. For most of the world's population it appears low on the horizon during the northern summer, below the hooked tail of Scorpius. However, in its northwest corner are some distant star clusters and associated clouds of dust that reveal surprising detail in a large telescope. This photograph was made in red light with the Anglo-Australian Telescope and shows a complex ridge of dust whose surface is illuminated by the two brightest stars in the picture. Though they dominate here, both are below naked-eye visibility.

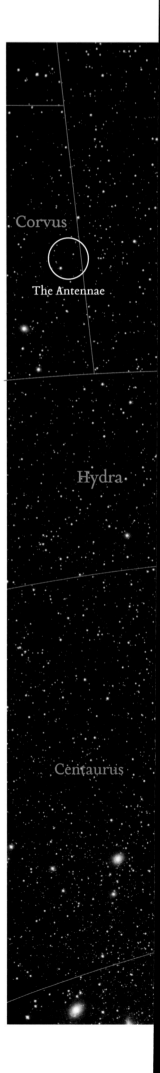

> When the 88 modern constellation outlines were formalized by the International Astronomical Union in the 1930s, the only one of Ptolemy's venerable 48 not incorporated whole was the gigantic sailing ship Argo Navis. The IAU broke up the mythical vessel of the Argonauts into four parts: Carina the keel, Vela the sails, Puppis the poop or stern, and Pyxis, the ship's compass, located improbably high above the mast. From the Mediterranean latitudes of ancient Greece, this celestial sailing ship must have tacked always close to the southern horizon, seemingly drifting on the numerous scattered stars of the sparkling southern Milky Way. Best seen from southern latitudes, this is a rich part of the sky, running south of Hydra (the Water Snake). The most striking object visible with the naked eye is the great nebula in Carina, an enormous star-forming region at a distance of 7,000 light years. Larger but much fainter are the tangled faint wisps of ancient light in Vela associated with the demise of a bright star 120 centuries ago. In adjoining Puppis, there are very faint dust clouds swept into cometary shapes by the energy from nearby stars, their long tails feebly reflecting their light. Some of the objects identified here also appear in other sections.

Wisps of Dust in the Sails of Argo Navis

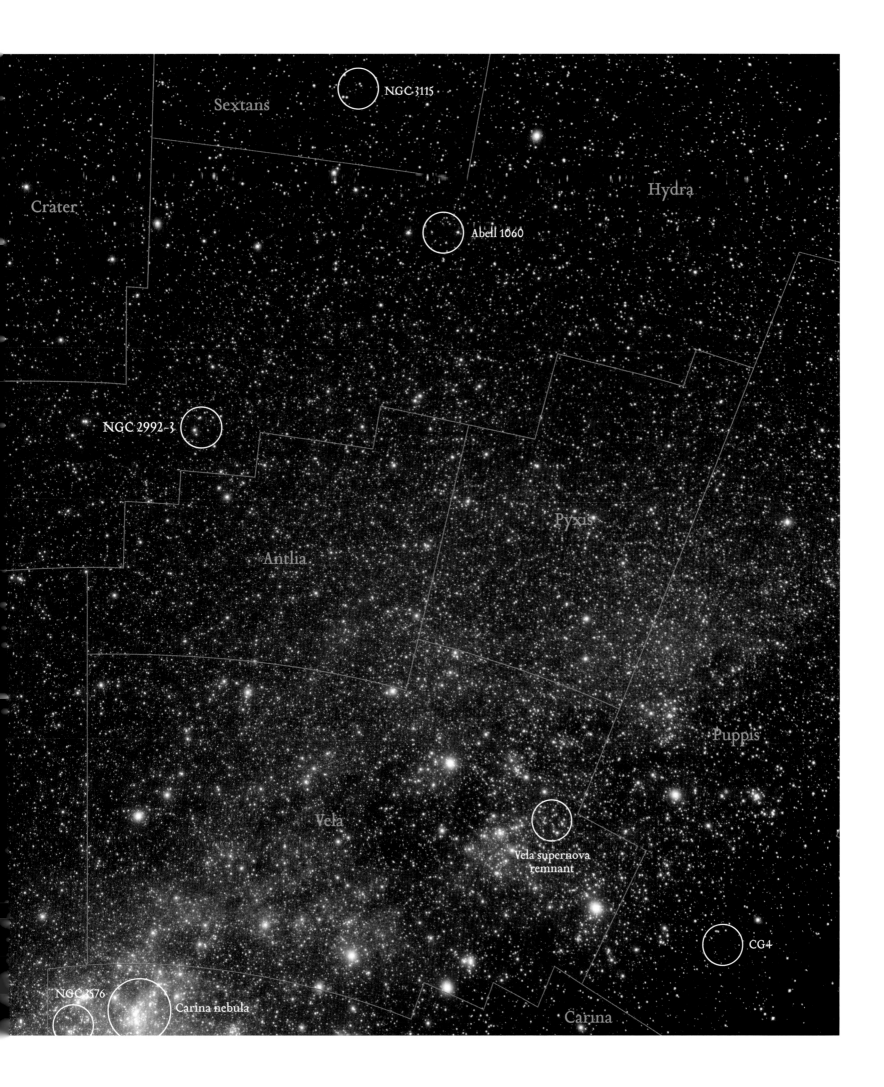

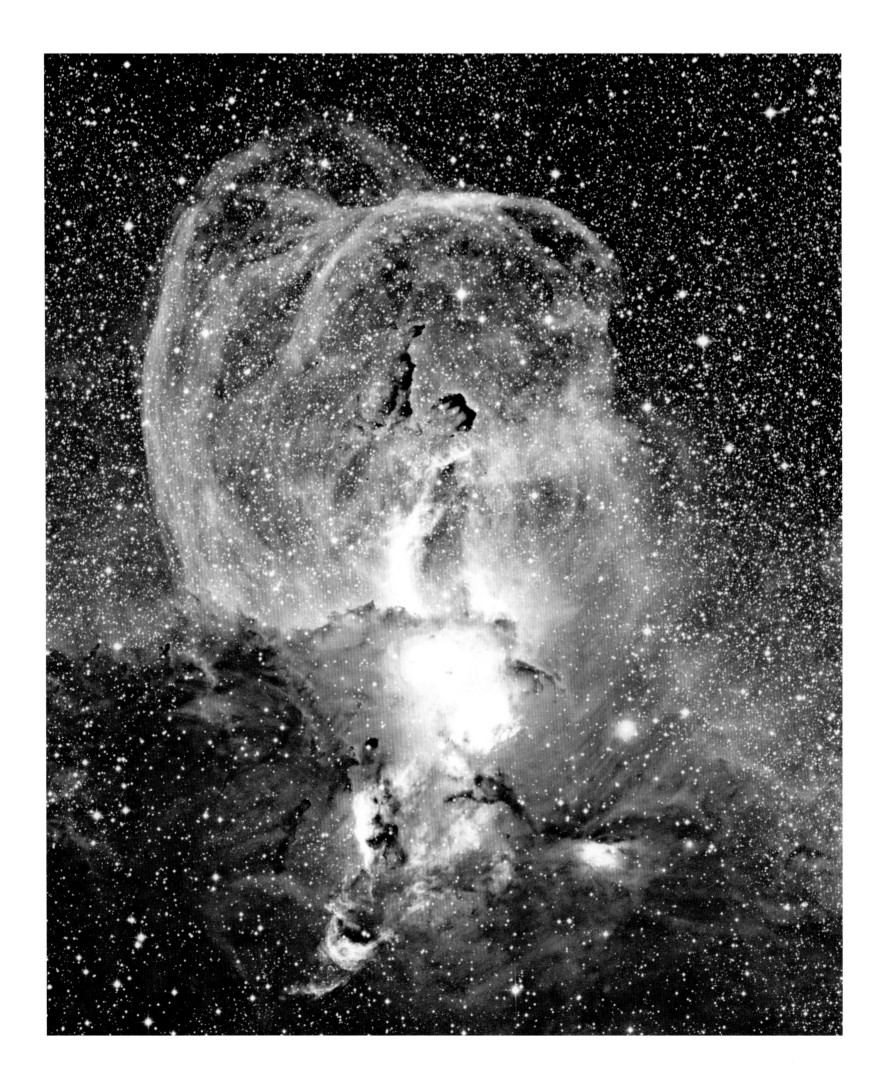

The loops of NGC 3576 in Carina

<

Stars are formed in the darkest, dustiest and coldest
parts of galaxies, so the early stages of star formation
are normally hidden from view. But as soon as stars
burst into life, their prodigious energy displaces the
dusty stuff that surrounds them. The young stars that
excite this curious object remain hidden in the brightest
parts of the nebula, but their energy has blown away
some of the dust at right angles to our line of sight, and
some shredded dusty fragments can be seen in silhouette
against an expanding, octopus-like shape, which was
photographed in red light.

The Great Nebula in Carina

>

The spectacular nebula in Carina is 7,000 light years
distant, but is easily visible to the unaided eye from the
southern hemisphere. It is a cloud of glowing gas
streaked with dust and home to Eta Carinae, one of the
most massive and unstable stars known. Though
it is difficult to see today, in the 1830s and 1840s Eta
brightened quickly, and for a few months in 1843
it was the second or third brightest star in the sky.
The brightening was the result of the star shedding
its outer layers, which expanded before they cooled
enough to shroud the star in a dusty cocoon and hide
its brilliance. The star is hidden in the brightest
part of the nebula shown here.

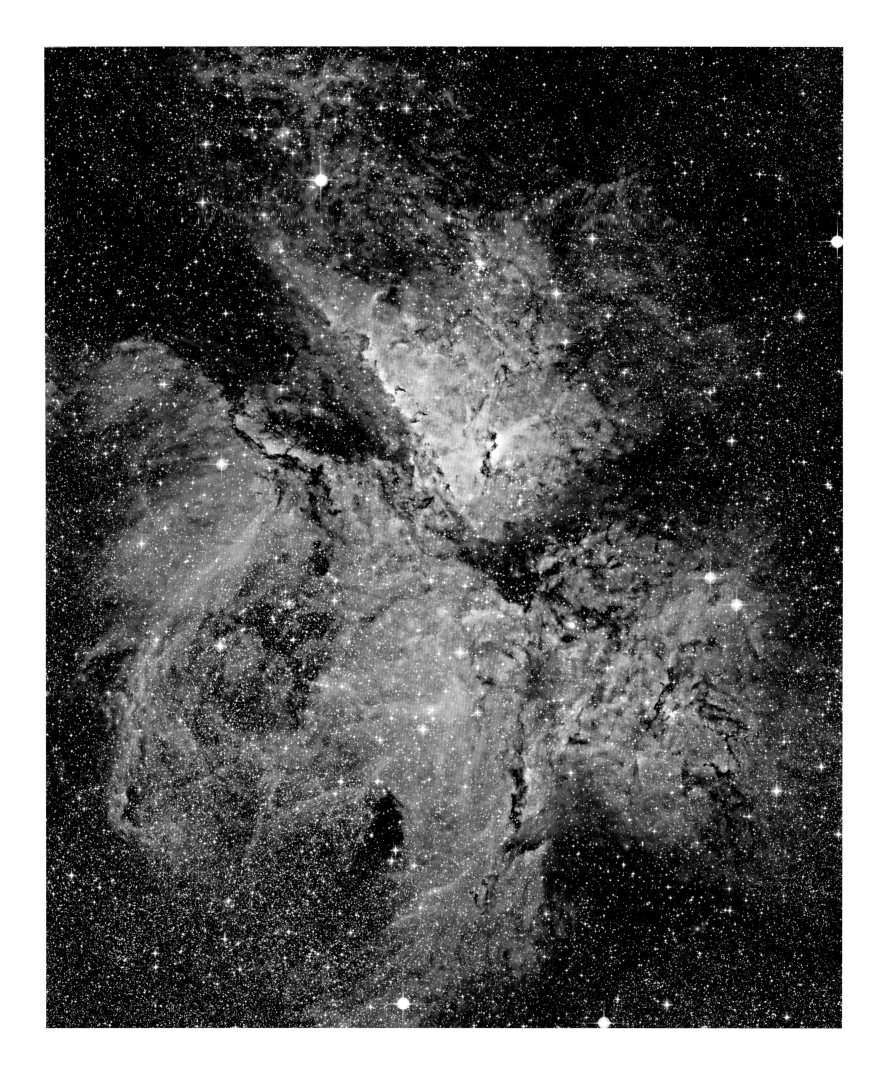

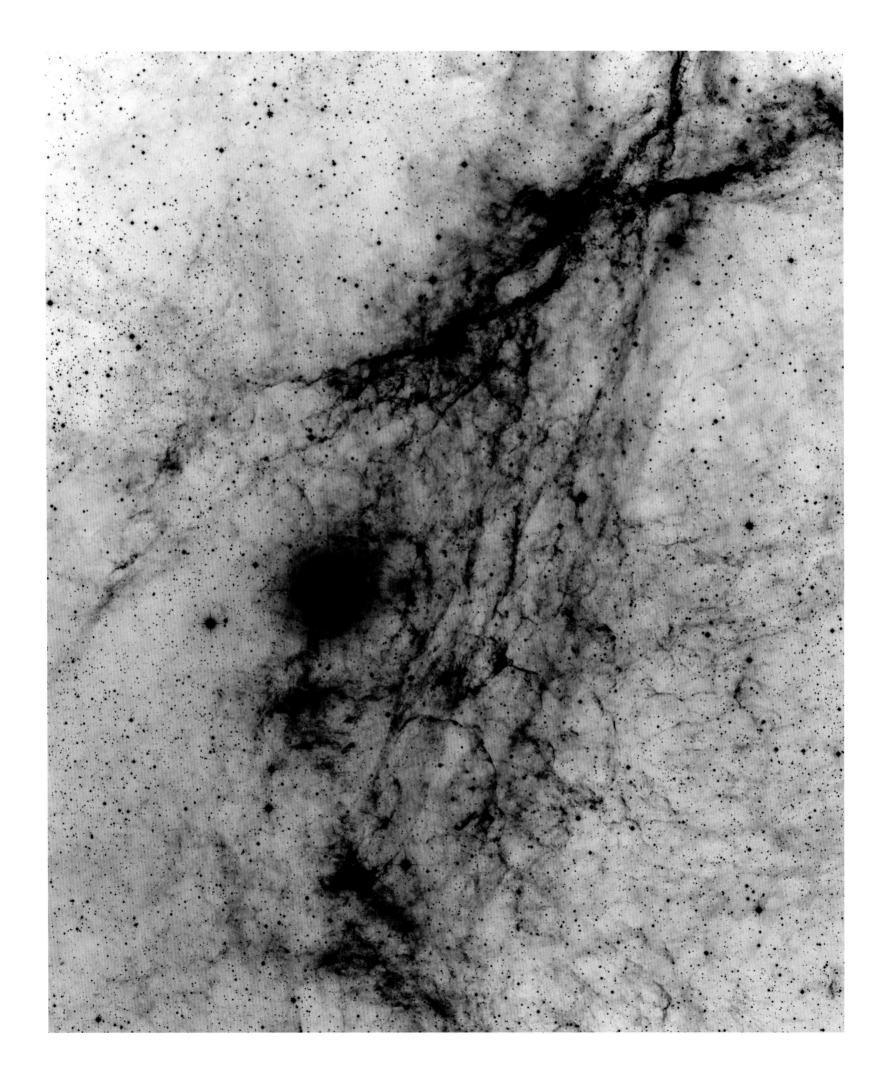

Vela supernova remnant (negative)

<

The southern constellation of Vela is in a rich part of the Milky Way streaked with faint red nebulosity and with many hot stars. Between the stars of the Milky Way drifts the tenuous interstellar medium, made up of traces of gas and dust, the debris from long-dead stars. Eventually this star stuff will condense into new stars, but while it is thinly spread it is normally very faint and difficult to see. The faintest nebula has a complex and interesting structure best seen on a photographic negative.

Vela supernova remnant (positive)

>

The brighter structure seen here is excited by a different source, the powerful shock wave from a supernova that exploded in Vela 120 centuries ago. As it courses through the interstellar medium, it excites the traces of hydrogen between the stars, revealing an intricate, lace-like structure. The nebulous region is quite thin, but where the glowing layer is seen edge-on it appears brightly, since we see into a greater thickness of it. This photograph was made with a filter that transmits the red light from the glowing gas but rejects most of the starlight, thus emphasizing the nebular details.

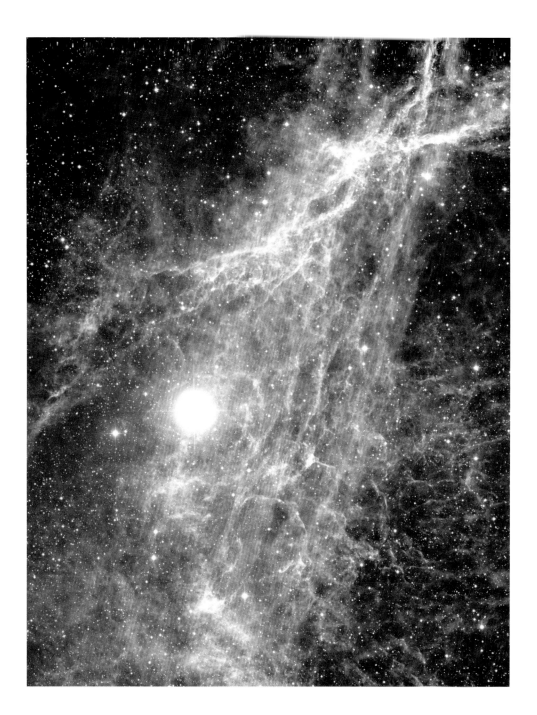

Vela supernova remnant, wide field

\>

A supernova event marks the catastrophic and explosive
end-point in the life of a massive star. The self-
destruction of the star releases a huge amount of energy
as radiation of all kinds, and creates the heavy elements
we find around us, including iron, copper, zinc, bromine
and iodine, all trace elements essential for life. These
elements did not exist before the stars made them. The
enormous energy of the supernova explosion scatters
the element-rich stellar debris far and wide in the
billowing, luminous clouds we see in this photograph.
These will eventually condense into cold, dusty clouds
of gas from which new stars and planets will appear.

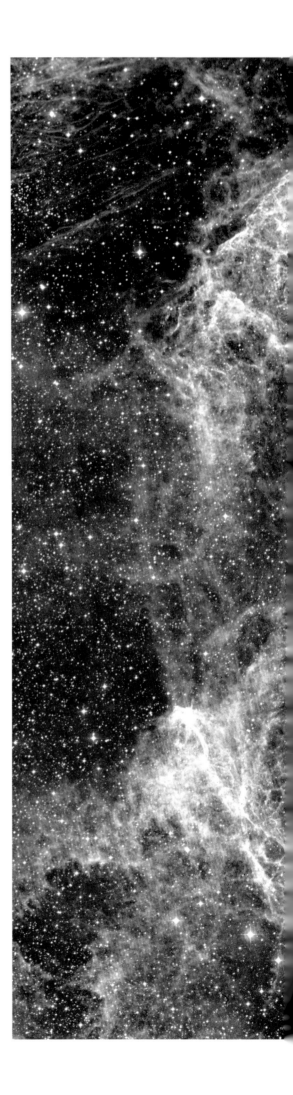

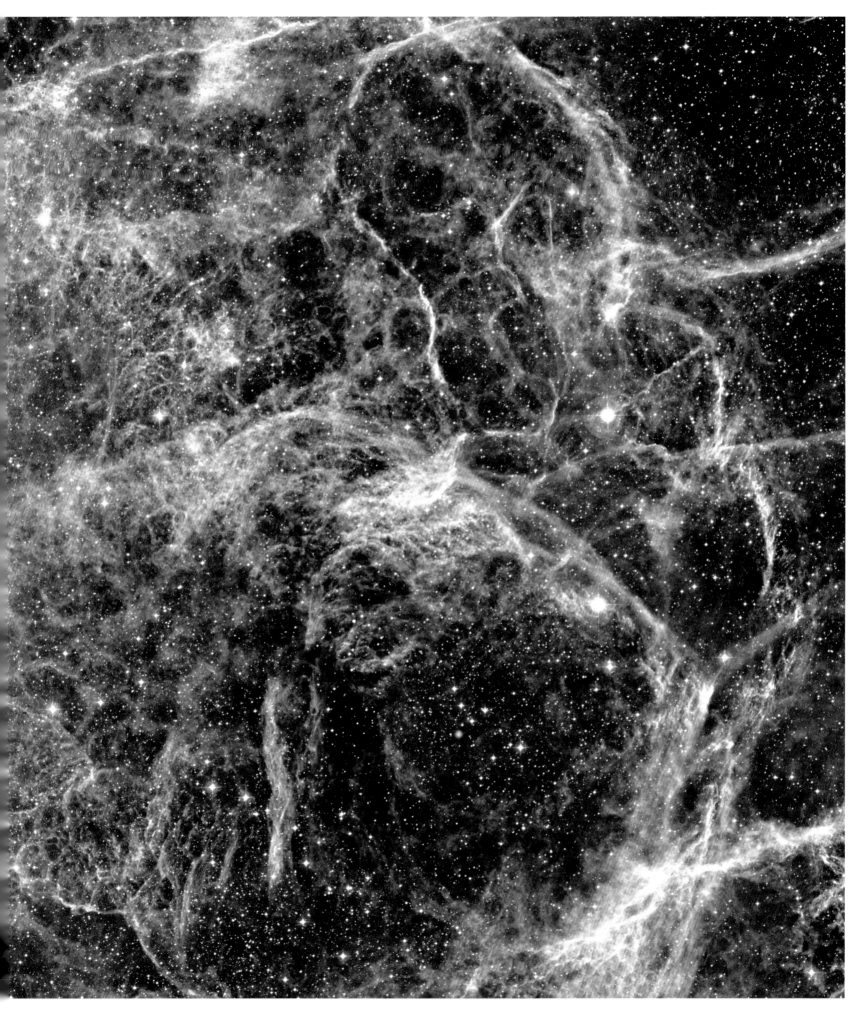

CG4, Cometary globule
'The Hand of God' in Puppis
>

Scattered among the myriad stars in the constellation
of Puppis are a few dense, isolated clouds of dust. They
are normally only visible because they block out the
light of stars beyond or because dust particles feebly
reflect the light from stars around them. However,
this curious nebula is a very faint patch of nebulosity,
illuminated by a nearby group of extremely hot stars
not visible here. Their radiant energy simultaneously
sculpts the dust into shape and in the process pushes
dust particles away, producing the faint elongated
outline seen here. Because of their extreme faintness,
cometary globules were not discovered until 1976.

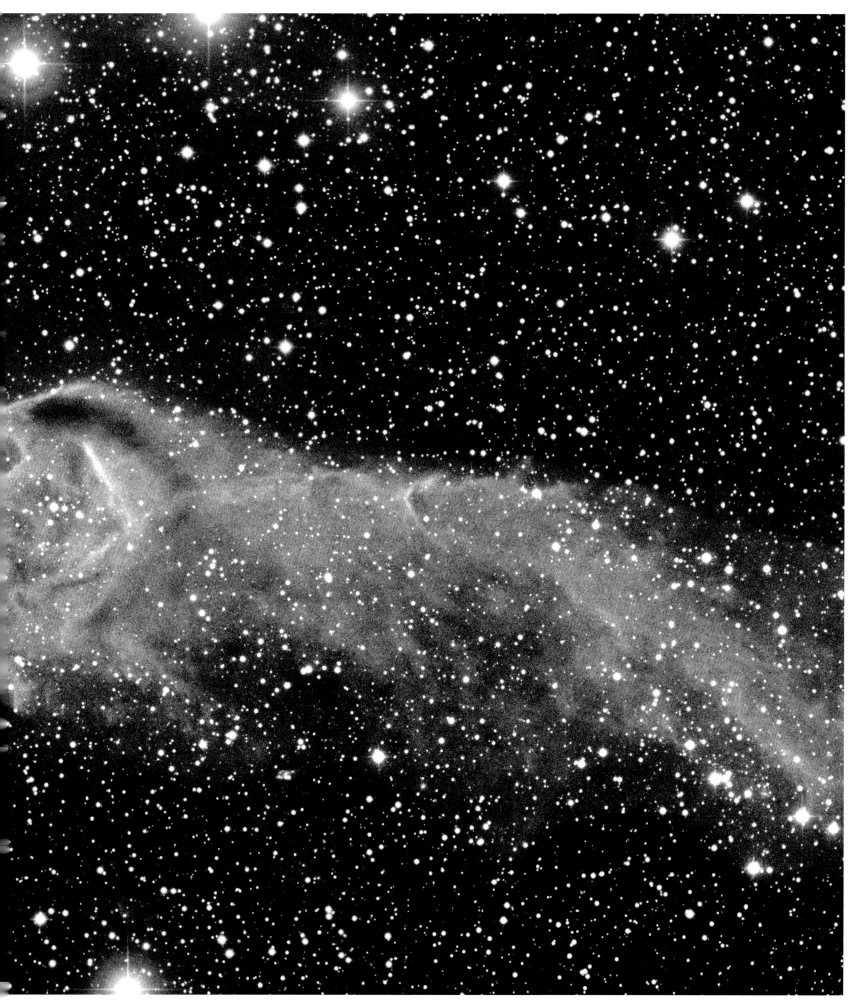

>

Hydra, the water snake, is the largest constellation in the sky, extending over 100 degrees, from Cancer to Lupus. Despite its enormous extent, it is quite difficult to find in the sky. To the ancient Greeks, the multi-headed Hydra guarded the Golden Fleece and the entrance to the Underworld. In another legend, it protects a cup of water (Crater, the goblet of Apollo) from adjoining Corvus, the crow, forever denying him a sip. A fresh-water serpent, Hydra was also the beast Hercules had to slay as the second of his twelve labours. This is perhaps a retelling of an earlier Babylonian story, in which the hero Gilgamesh kills a many-headed monster. In the seventeenth century, the Polish astronomer Hevelius introduced Sextans in the barren part of the sky south of the ancient constellation of Leo the lion, commemorating the instrument he used for measuring star positions. The galaxies in this part of the sky are many, varied and interesting. While both the Sombrero galaxy (M104) and NGC 3115 are readily seen in small telescopes, the faint features of the interacting Antennae are challenging for any instrument. The others are included for their unusual appearance and visual variety. This wide-field photograph partly overlaps that from the previous section, but identifies only the galaxies.

The Galaxies of Sextans, Hydra, Virgo & the Crow

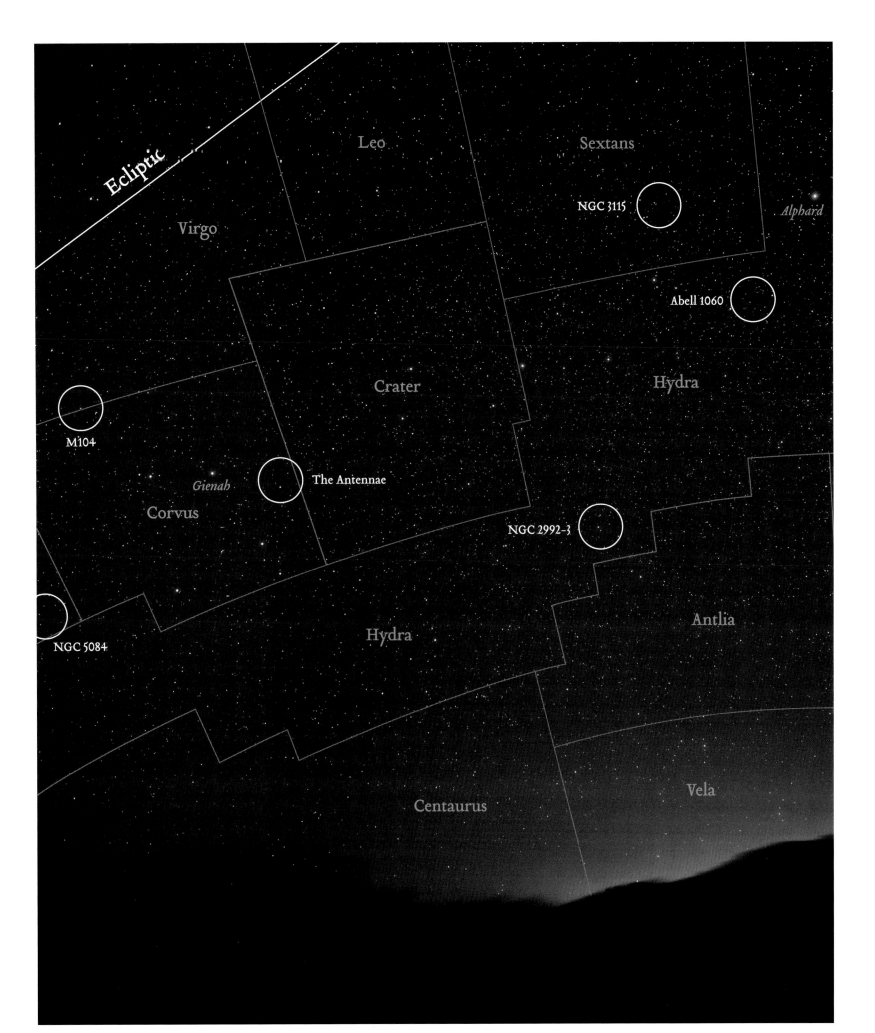

Ecliptic

Leo

Sextans

Virgo

NGC 3115

Alphard

Abell 1060

Crater

Hydra

M104

Gienah

The Antennae

Corvus

NGC 2992-3

NGC 5084

Antlia

Hydra

Centaurus

Vela

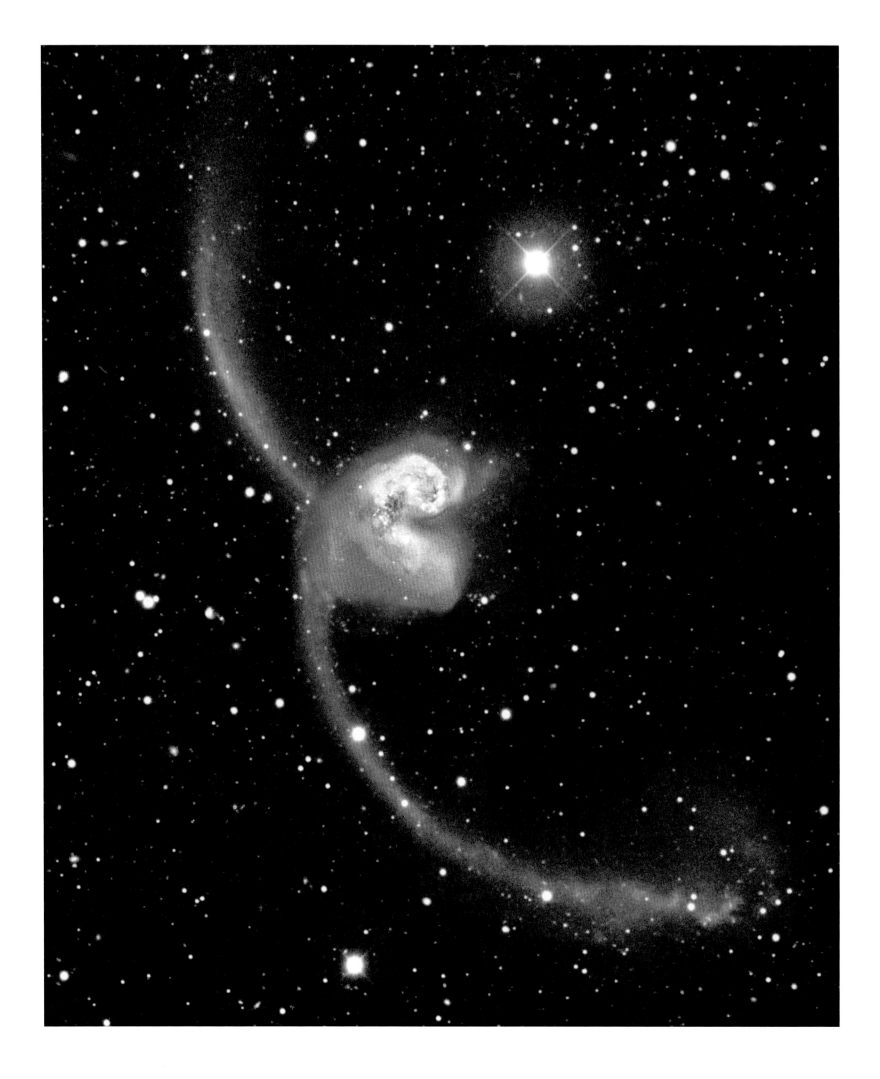

The Antennae, interacting
galaxies in Corvus

<

Galaxies are rarely found in isolation, rather they
are gregarious and tend to gather in pairs, groups
of a few and rich clusters, held together by their
mutual gravity. Not surprisingly, galaxies often come
together, and what happens next can be spectacular,
depending on the circumstances. In this photograph
two rotating spiral systems have met recently
– within the last 500 million years – and their
interaction has ejected curved streams of stars and
triggered vigorous star formation; the results are seen
as clumps in the brightest part of the photograph. In
another billion years the galaxies will have merged
and reabsorbed most of the stars they have ejected,
creating a normal-looking galaxy with an interesting
history. The Antennae galaxies are about 45 million
light years distant.

NGC 3115 , an S0 galaxy
in Sextans

>

Classifying galaxies has been (and remains) an
important part of understanding them. The broad
categories of elegantly structured, disc-like spirals and
the featureless fuzzy spheroids of ellipticals are easy
enough, but there are many subtypes and intermediate
varieties that reveal much about galactic evolution.
Here we see a galaxy that has the thin disc of a spiral
(seen edge-on) but no obvious inner structure or hint
of star formation that distinguishes a normal spiral
galaxy. It does not, however, look like an elliptical
either. Such galaxies are known as 'S0' or 'lenticular'
(lens-shaped) galaxies and are possibly spiral galaxies
that have been stripped of their gas and dust by
gravitational interactions with other galaxies.

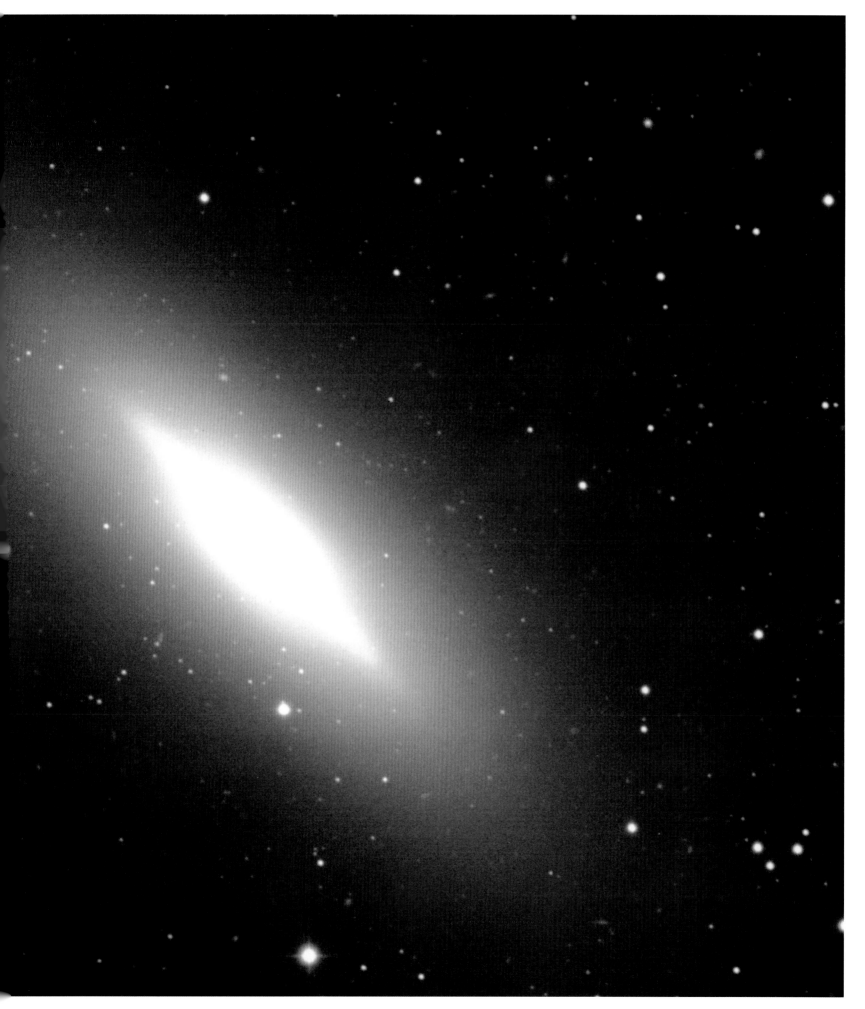

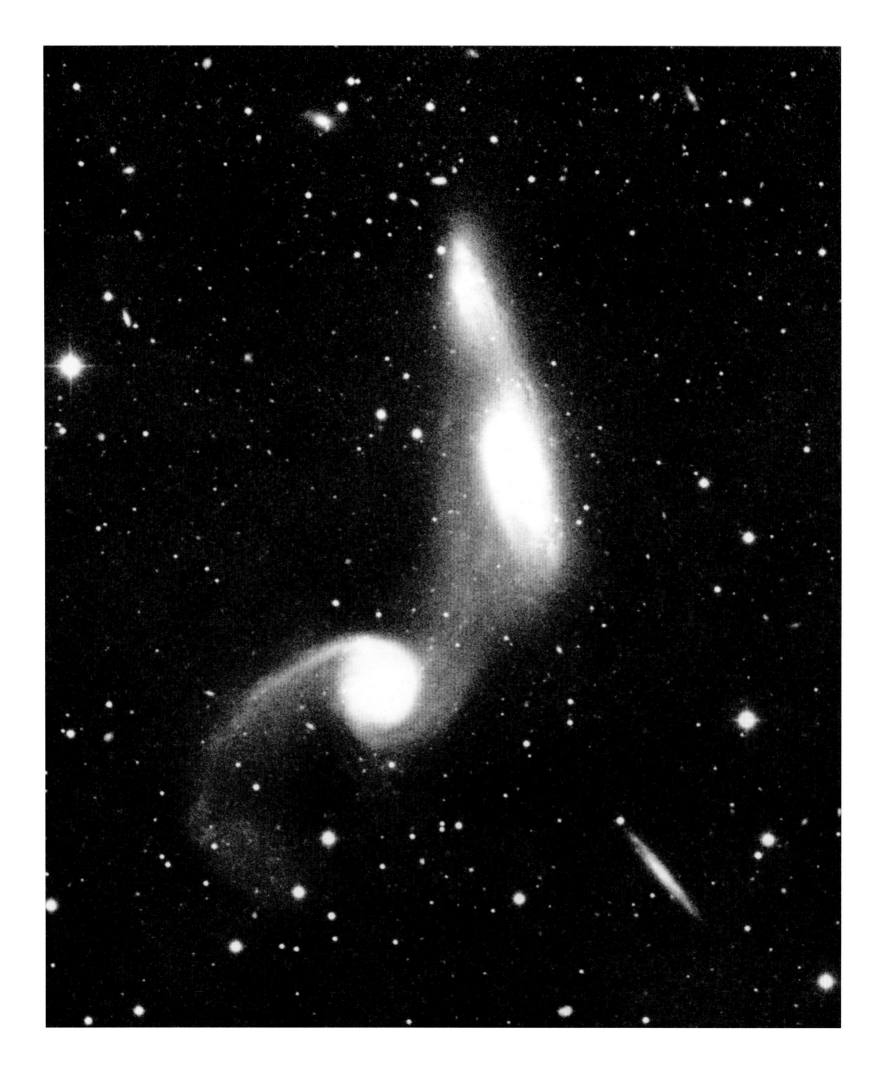

NGC 2992-3, interacting galaxies in Hydra

<

Galaxies are by nature gregarious, attracted by their
mutual gravity. Sometimes close encounters are
disruptive and streams of stars are displaced as they
interact. Though the catalogue name implies two
objects, in fact there are three galaxies here, locked in
a permanent embrace, and over the next several billion
years they will merge into a single body, recapturing
most of the displaced stars. These stretched-out
galaxies are located together in space about
100 million light years away.

Abell 1060, a galaxy cluster in Hydra

>

This beautiful, compact cluster of galaxies is in the
winding southern constellation of Hydra, and the
galaxies are at a distance of about 150 million light years.
Groups of galaxies are common and often have mixed
populations, with the fuzzy elliptical galaxies being
more numerous than the structured spirals, as here.
More numerous still in clusters are the dwarf elliptical
galaxies, seen as faint, fuzzy patches of light. They are
composed of millions of stars rather than the billions
found in the handful of giant ellipticals
in this picture.

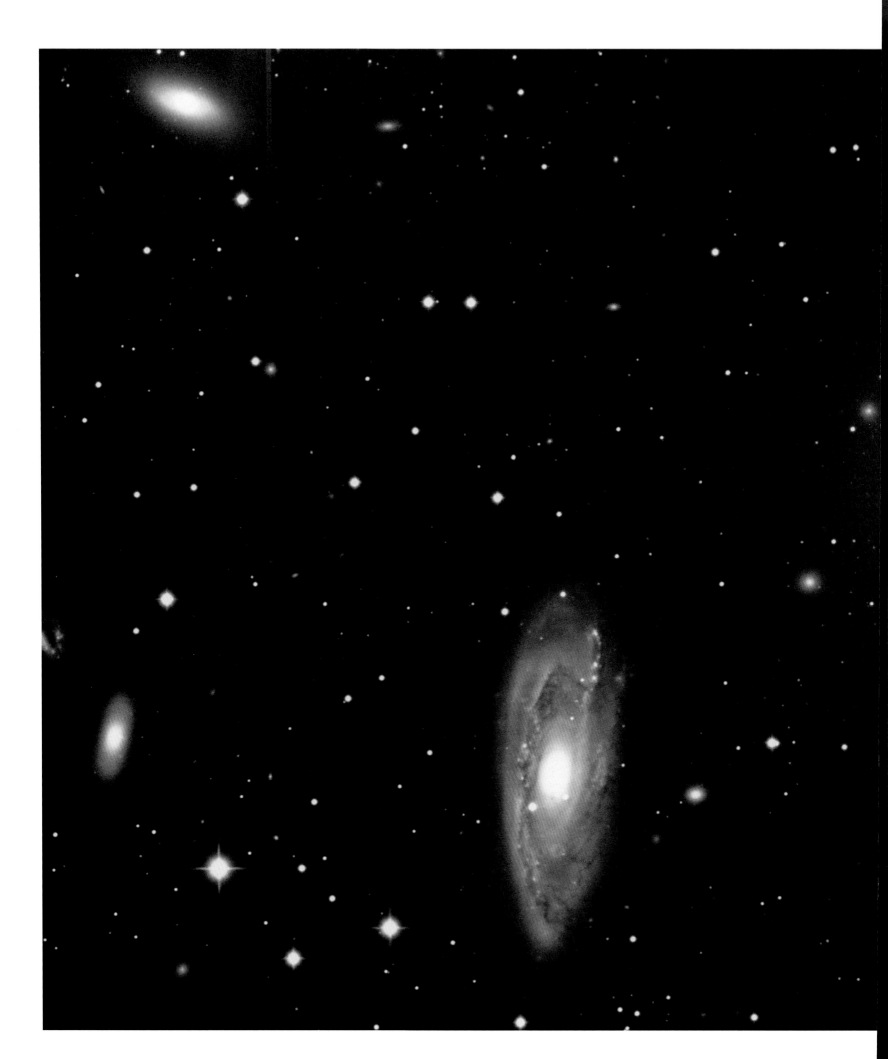

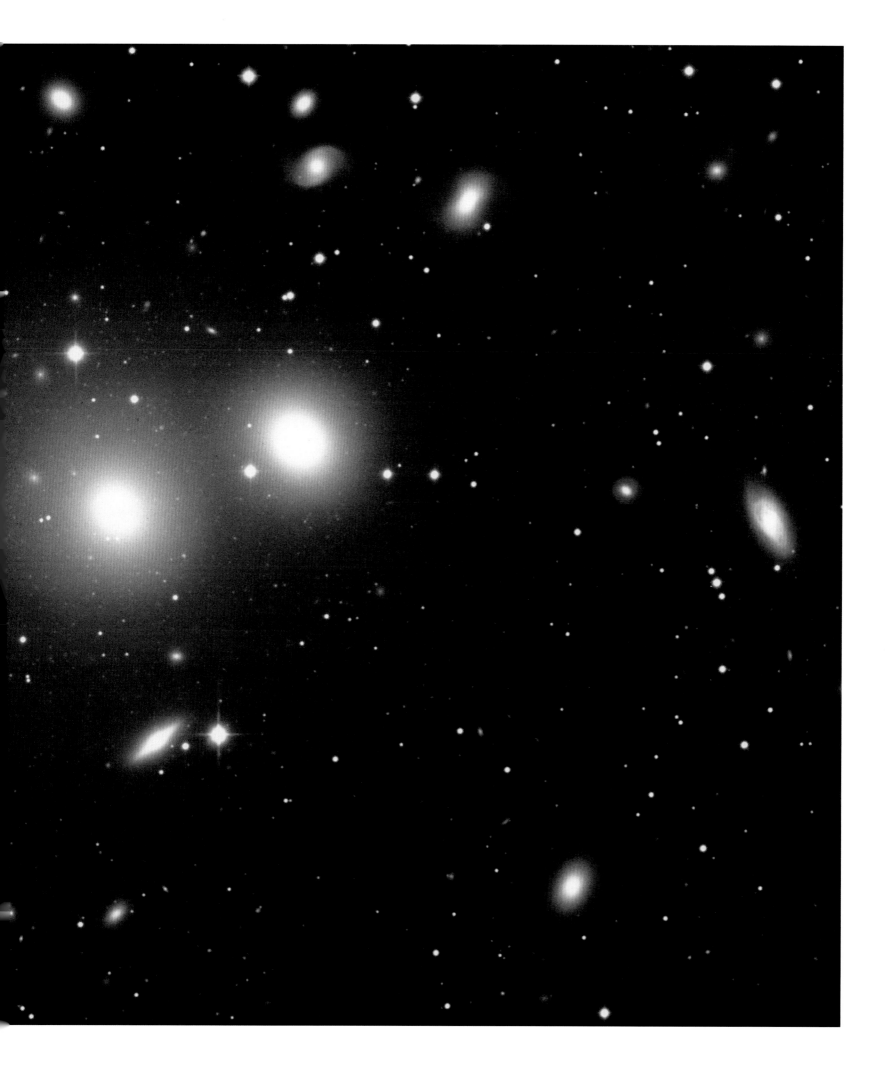

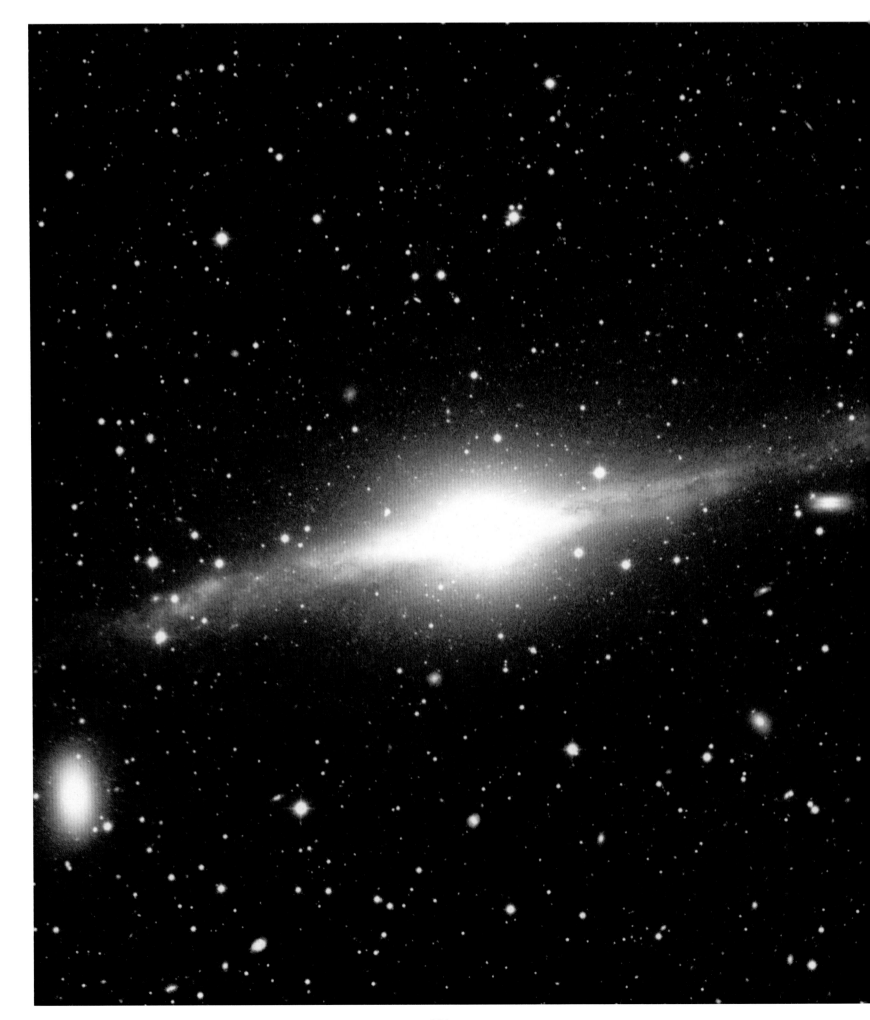

NGC 5084,
a massive, edge-on galaxy in Virgo

<

NGC 5084 is one of the most massive disc galaxies
known, with at least 10 times more stars than the Milky
Way, itself a substantial galaxy. We see it in the direction
of Virgo at a distance of 50 million light years. The
galaxy has an unusually pronounced central bulge,
and the faint, clumpy spiral arms are seen edge-on.
Virgo is rich in galaxies of all sizes, so we should not be
surprised to see many in this picture. However, several
of the brightest here are in the process of being absorbed
by NGC 5084, creating an even more massive galaxy
and no doubt further disturbance of the faint disc.

M 104, the Sombrero galaxy, in Virgo

>

The Sombrero galaxy is fancifully named for its
resemblance to a broad-brimmed Mexican hat. The
diffuse central bulge that dominates the picture is the
light of billions of stars in orbit around an unseen Black
Hole at the heart of the galaxy. The bulge is crossed
by a narrow lane of dust that absorbs light from an
almost edge-on spiral disc, while the scattering of
individual stars seen here belong to our own Milky Way.
The Sombrero galaxy is about 65 million light years
away in the direction of Virgo. As in most branches of
photography, the perception of an image is strongly
influenced by its setting. This tight cropping of the
beautiful Sombrero galaxy emphasizes its form and
texture. Choosing a wider view would give the visual
impression of the same galaxy adrift in the emptiness
of space, in much the same way that in 1755 the German
philosopher Immanuel Kant used the phrase 'island
universe' to speculate on the nature of the nebulae that
astronomers were beginning to discover.

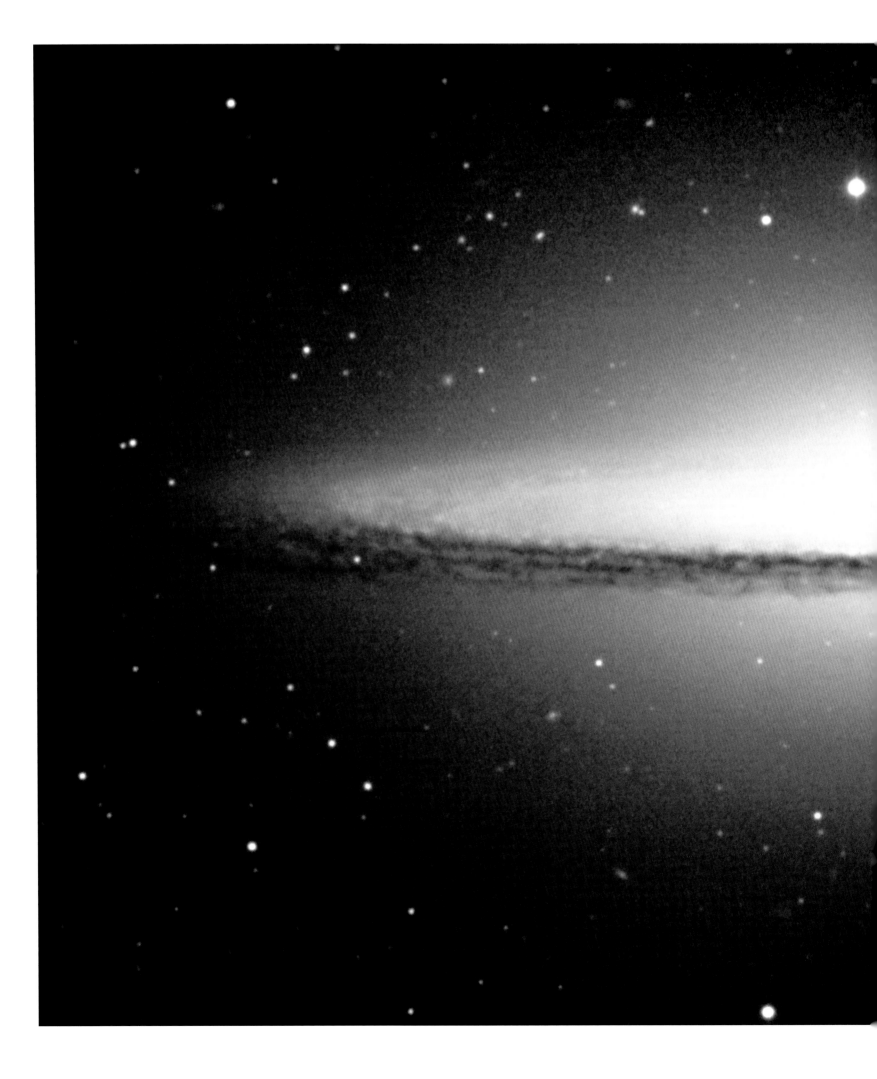

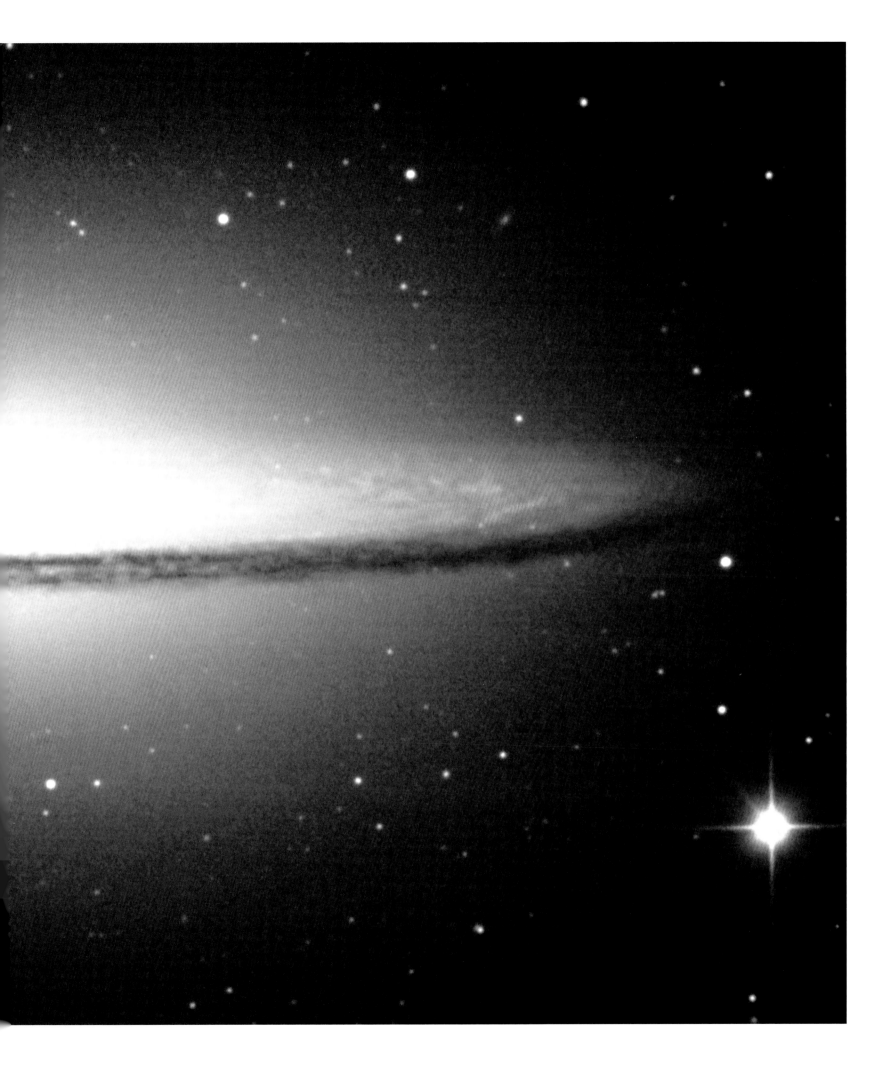

Like the previous picture of Sextans and Hydra, this wide-angle photograph was taken from the northern hemisphere and looks south to the sky on the horizon. The eastern end of the tail of Hydra forms the northern border of Centaurus, which represents a centaur in Greek mythology: a creature that is half man, half horse. The learned centaur is the legendary inventor of the main constellations, which is perhaps why there is another such creature in the sky, the threatening figure of Sagittarius, the archer. Here we have marked the Ecliptic, the path of the Sun, passing through the zodiacal constellations of Scorpius, Libra and finally Virgo, which is particularly rich in galaxies. A scattering of nearby galaxies extends southwards from Virgo into Hydra and Centaurus, where we find the beautiful spiral galaxy M83 and the nearest strong radio galaxy, the enigmatic Centaurus A (NGC 5128). At the eastern end of the photograph are the dusty reflection nebulae associated with the star Rho Ophiuchi. These are unrelated to the spectacular bright star Antares, which lies in the body of the scorpion. Scorpius once extended into what is now Libra, leaving behind the resounding Arabic names of the stars Zeuben Eschamali (meaning northern claw) and Zeuben Elgenubi (southern claw).

Antares & the Tail of the Sea Serpent

Serpens Caput

Virgo

Ecliptic

Ophiuchus

Zueben Eschamali

Spica

Libra

Zeuben Elgenubi

Hydra

Dscubba

Rho Ophiuchi nebula

M83

Antares

Centaurus

Scorpius

Lupus

NGC 5128

NGC 5189i

NGC 5128 (Centaurus A) in Centaurus

>

This peculiar shape in the sky is famous among
astronomers for several reasons. It was first noted
as unusual in a drawing by a Scottish astronomer,
James Dunlop, working in Australia in about 1826.
Over a century later, in 1948, it became the first
radio source discovered beyond the Milky Way, by
Australian radio astronomers. This accounts for its
second designation (Centaurus A) as the strongest
radio source in that constellation; indeed it is the
strongest extragalactic radio source in the sky. The
radio energy results from violent activity in the
galaxy's nucleus and emerges as jets that extend over
at least 10 degrees of the southern sky, far beyond the
confines of this visible light photograph.

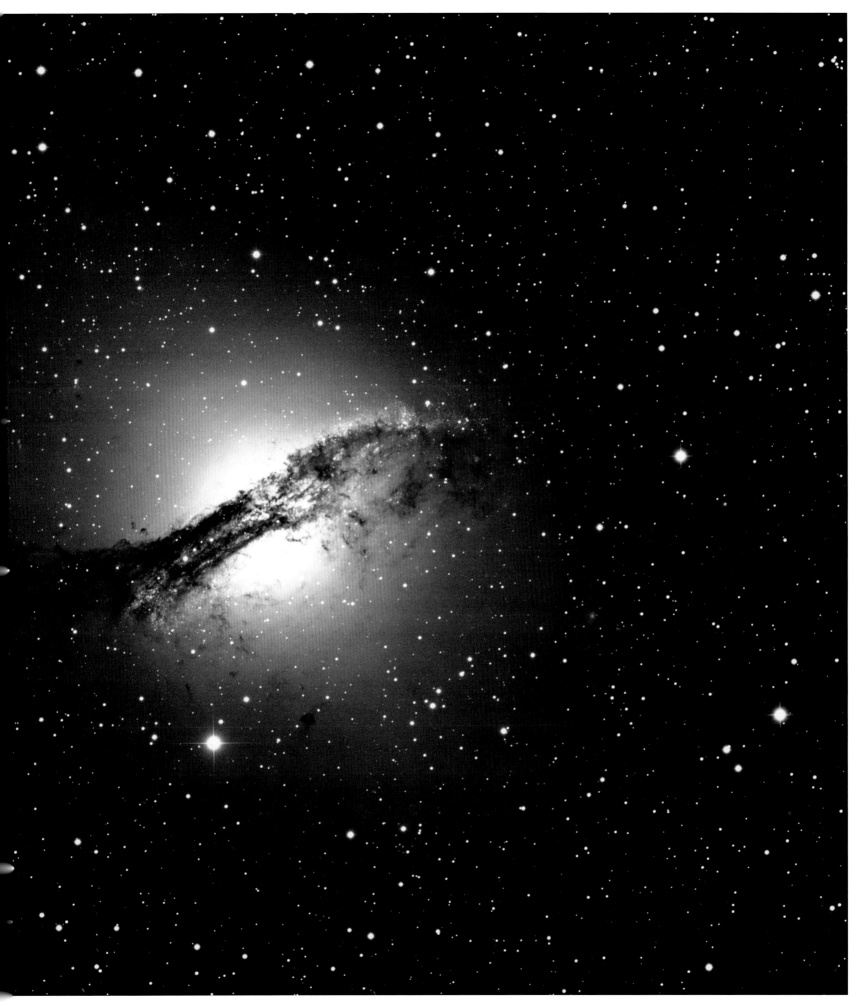

NGC 5189 (Omega Centauri) in Centaurus

>

Omega Centauri was discovered in 1677 by Edmund
Halley, of comet fame. It has a star's name, but even
seen with the naked eye, this looks like no normal star.
It appears as a faint, fuzzy blob, rather like the nucleus
of a comet, with which it has been occasionally
confused. Omega Centauri is one of the finest globular
clusters in the southern Milky Way, and has no equal
in the northern sky. It is a gathering of millions of
mostly ancient stars at a distance of about 18,000 light
years. These stars formed billions of years before the
Sun and its retinue of planets appeared.

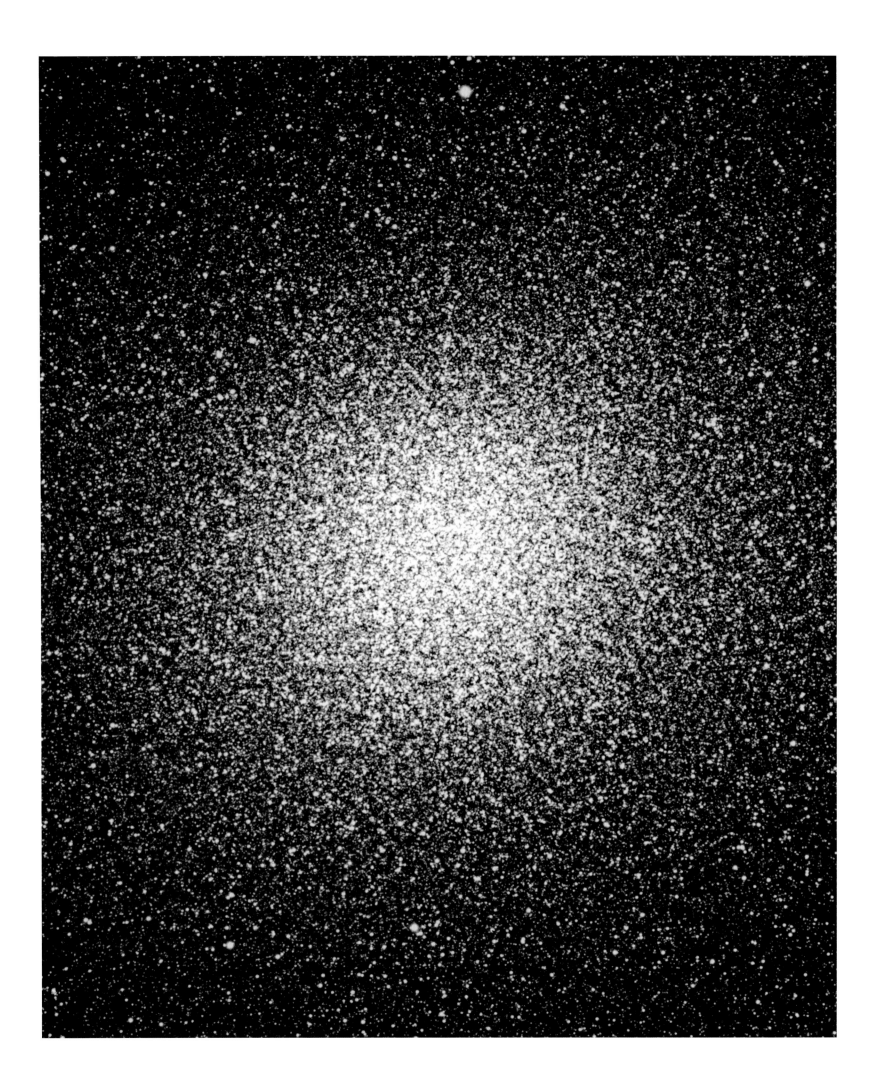

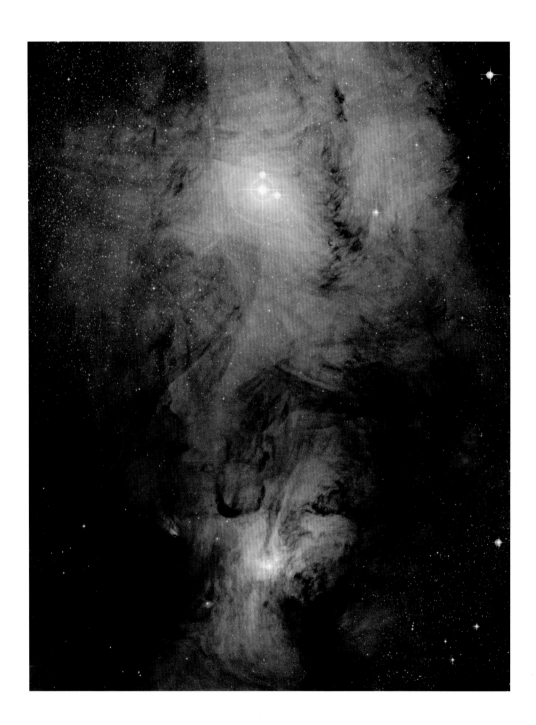

The Rho Ophiuchi reflection nebula,
fine structure, in Ophiuchus

<

The star Rho Ophiuchi is embedded in
the outskirts of a dusty cloud. The light
from Rho and another bright star at the
bottom of the picture is reflected from criss-
crossing sheets of dust, revealing a complex
striated structure that is emphasized here by
employing a special photographic copying
technique using an unsharp mask, which is
a blurred positive copy of the original glass
negative. By changing the extent of blurring
in the mask either the fine structure (as
here) or coarser detail can be uncovered.

The Rho Ophiuchi reflection nebula,
coarse structure, in Ophiuchus

>

Both this image and the previous one
are derived from the same original plate
made on the UK Schmidt Telescope. This
photograph shows the coarser detail in
the dust, and reveals how it is layered.
The extent of layering is more or less
constant across the picture, suggesting that
Rho Ophiuchi is simply illuminating the
dust cloud rather than disturbing it. The
photographic processes are non-destructive
to the original plate and do not affect the
appearance of the myriad background stars
of the Milky Way, which are seen in both
pictures where the dust is less dense.

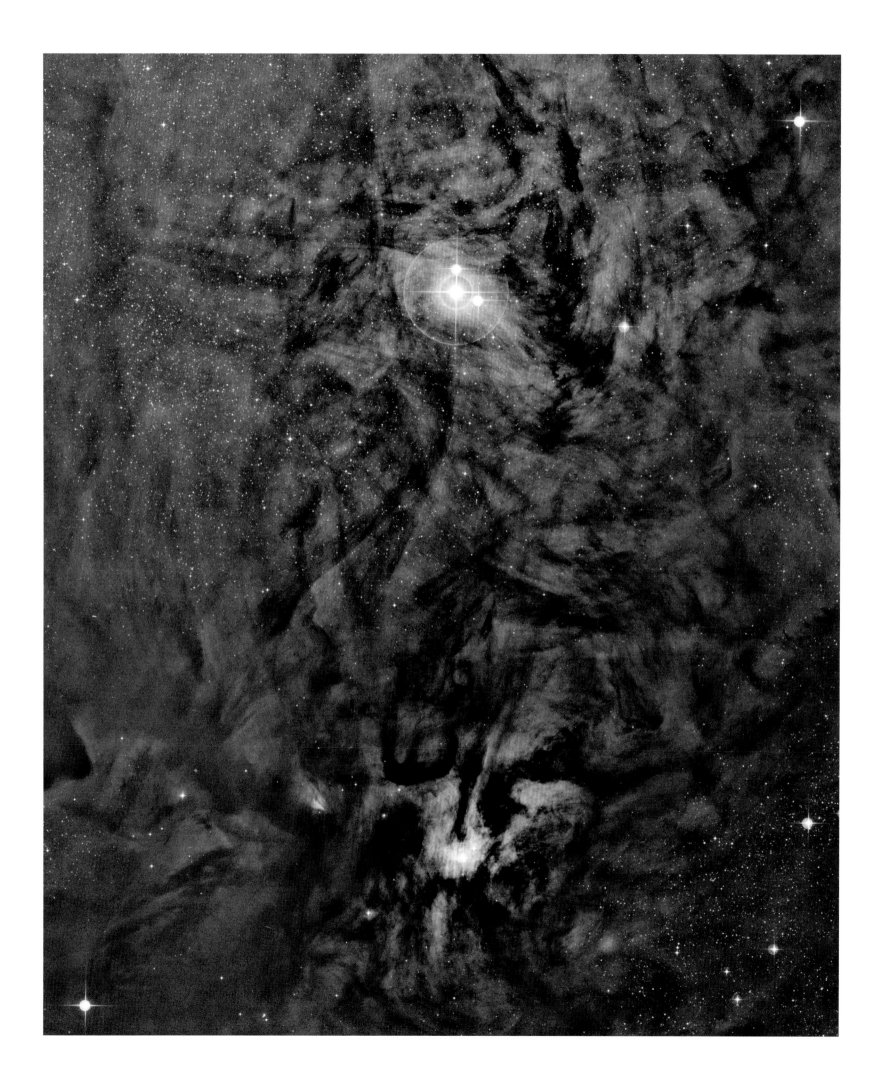

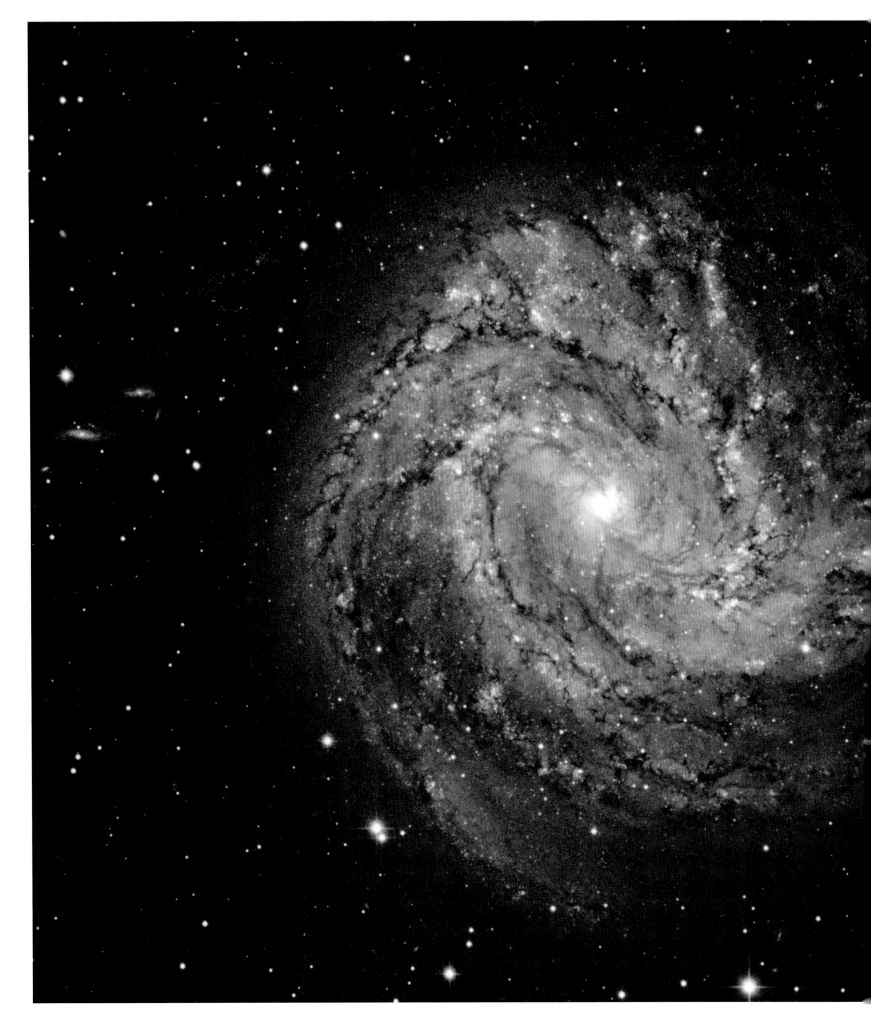

M83, a spiral galaxy in Hydra

<

Hydra, the water snake, is the largest constellation in
the sky and it shares a long border with Centaurus,
which is almost as big. Straddling the boundary we
find a beautiful nearby spiral galaxy, M83. M83 is a
galaxy of stars, gas and dust like the Milky Way and
we see it almost face-on at distance of about 20 million
light years. Any inhabitants of M83 might see our
galaxy just as well as we see theirs, but the Milky Way
would be inclined to their line of sight, rather like the
two distant galaxies that appear close to M83, to the left
of the disc.

M83, a spiral galaxy
in Hydra, as a negative

＞

Negatives are how astronomers are accustomed to
viewing their images. It is quick and convenient of
course to use the original plate, but a negative also
reveals faint features more readily and that is especially
true of images of galaxies such as this. With galaxies
at this distance some of the brighter stars can be
distinguished, but they are small and faint and often
embedded in bright nebulosity. They are much more
easily seen on a negative, as are the faint extensions or
distortions that reveal so much about a galaxy's history
and environment. Finally, on deep images such as this,
many faint background galaxies are visible that would
be lost in a positive print.

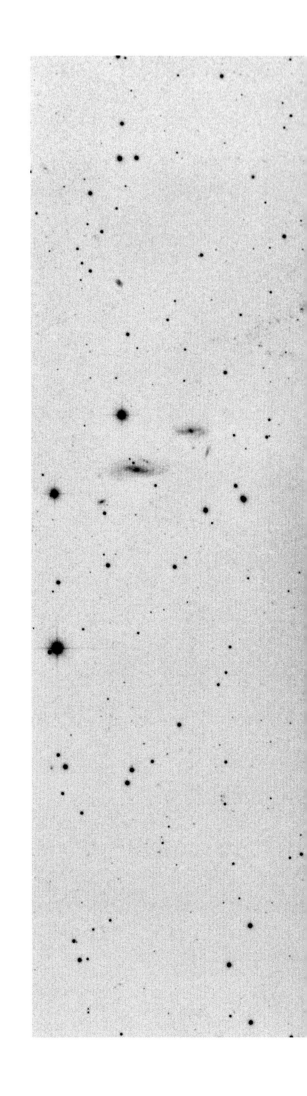

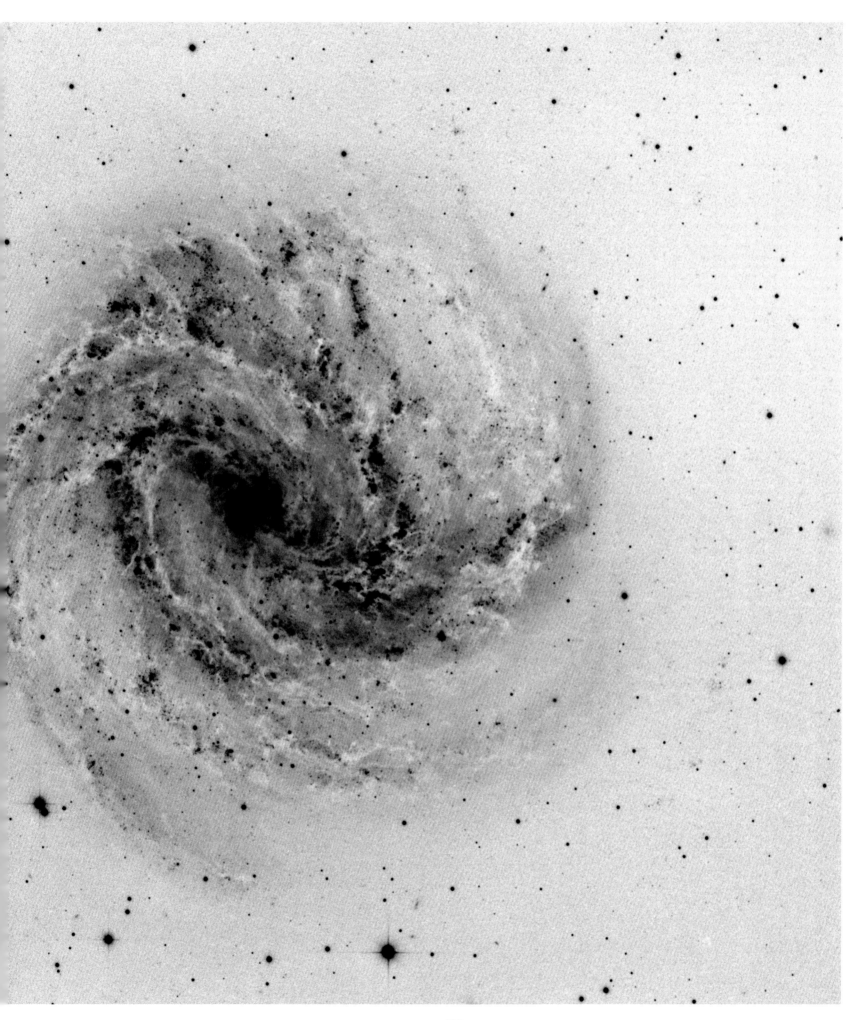

\>

Orion the Hunter is one of the best known of the constellations. Its distinctive line of three stars sits astride the Celestial Equator, and they mark due east and west as they rise and set. The stars of Orion's Belt are framed by an irregular rectangle of other bright luminaries and to the south lies Sirius, the brightest star of all. Orion's equatorial location ensures that it is visible from all inhabited parts of the world. There are many myths about this beautiful collection of stars, but the most common Greek legend has Orion as a giant huntsman and he appears in this role in Homer's *Odyssey*. He is said to have died from the sting of a giant scorpion, which was placed in the sky so that Orion sets as Scorpius rises, in an eternal chase across the sky. To the northwest (upper right) of Orion is Taurus (the bull) where we find two other well known star clusters. The Hyades capture the V shape of the bull's head and horns, with the bright orange star Aldebaran as his fiery eye. Towards the northwest corner of the picture we see the delicate beauty of the Pleiades, the Seven Sisters, daughters of Atlas and Pleione.

Capella to Sirius & the Stars of Orion

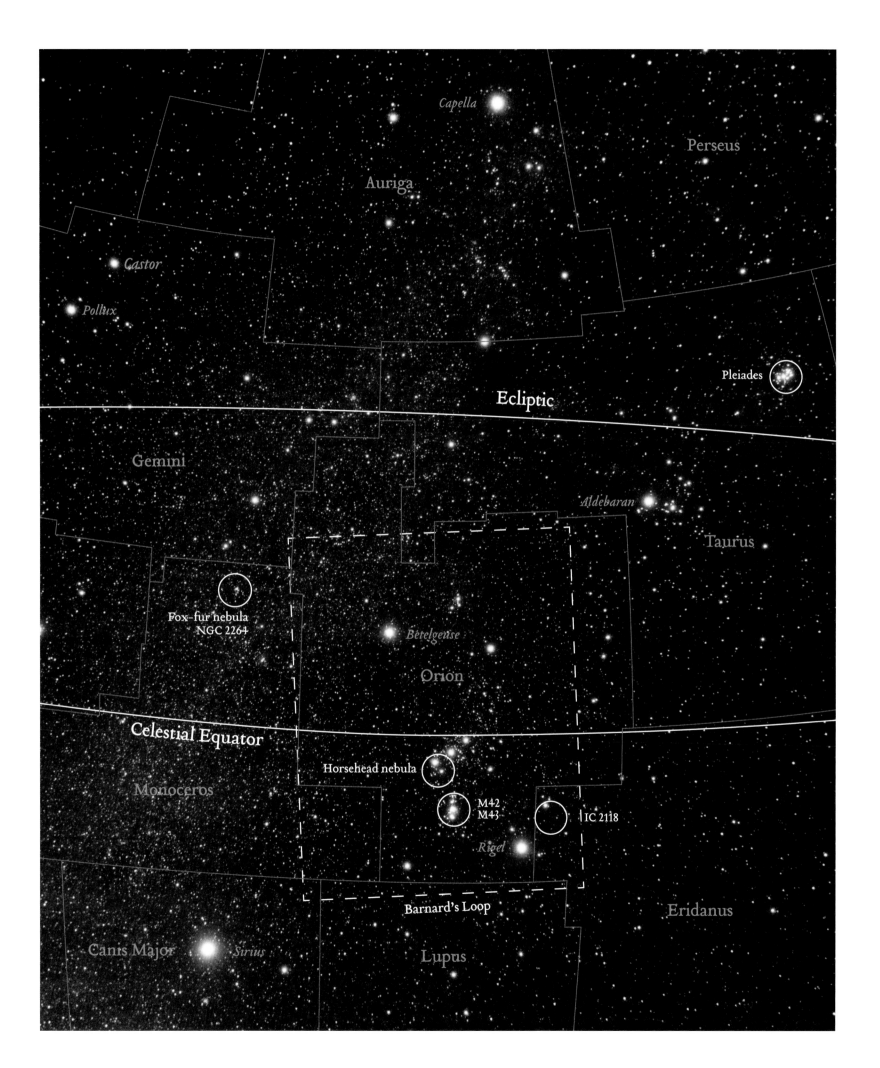

Capella

Perseus

Auriga

Castor

Pollux

Pleiades

Ecliptic

Gemini

Aldebaran

Taurus

Fox-fur nebula
NGC 2264

Betelgeuse

Orion

Celestial Equator

Monoceros

Horsehead nebula

M42
M43

IC 2118

Rigel

Barnard's Loop

Eridanus

Canis Major

Sirius

Lupus

IC 2118, the Witch's Head nebula, in Eridanus
>
This remarkable, unworldly shape
is dust reflecting the light of Rigel, one of the brighter
stars in the constellation of Orion, though the nebula
itself is in the neighbouring constellation of Eridanus.
The surface of the nebula has probably been etched into
this unusual shape by the radiation from Rigel, which
is a particularly energetic, super-giant star. Despite the
impression given here, the fancifully named Witch's
Head nebula is quite faint and in reality quite blue, since
the reflecting dust particles are more akin to smoke
than to the dust of the desert. Both the nebula and
Rigel are at a distance of about 800 light years.

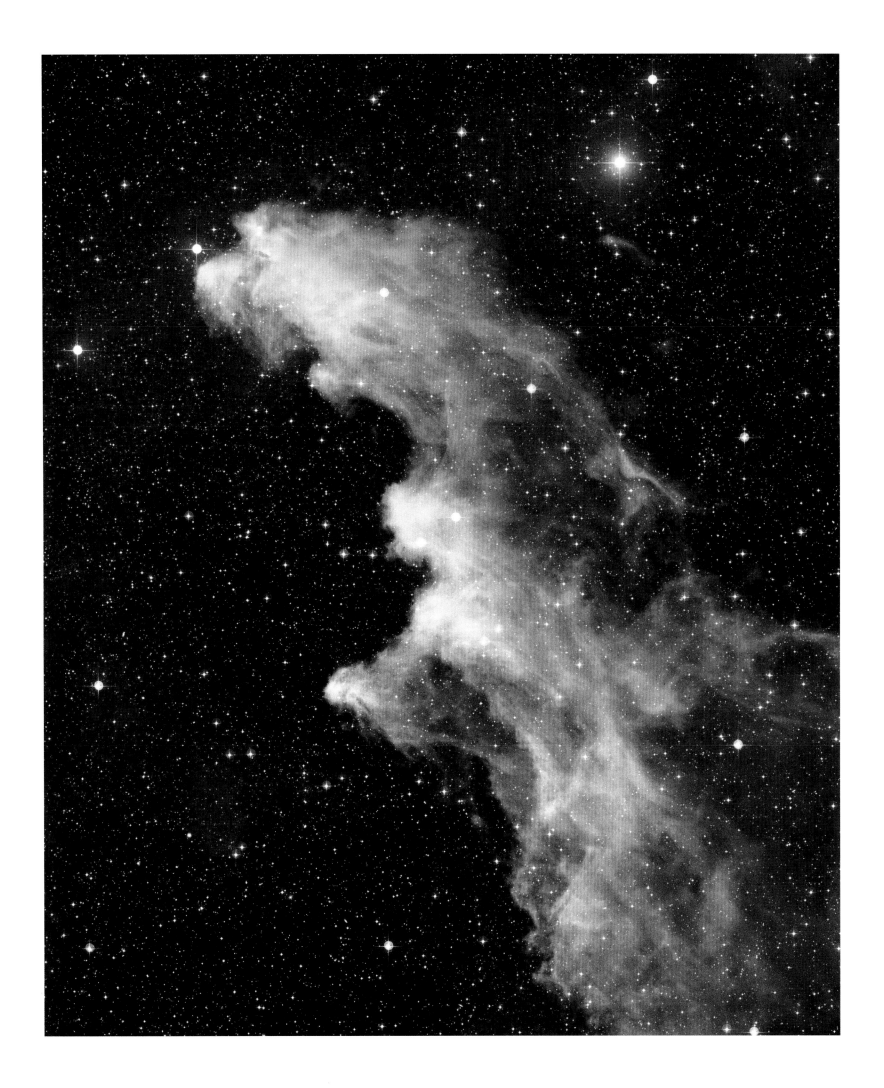

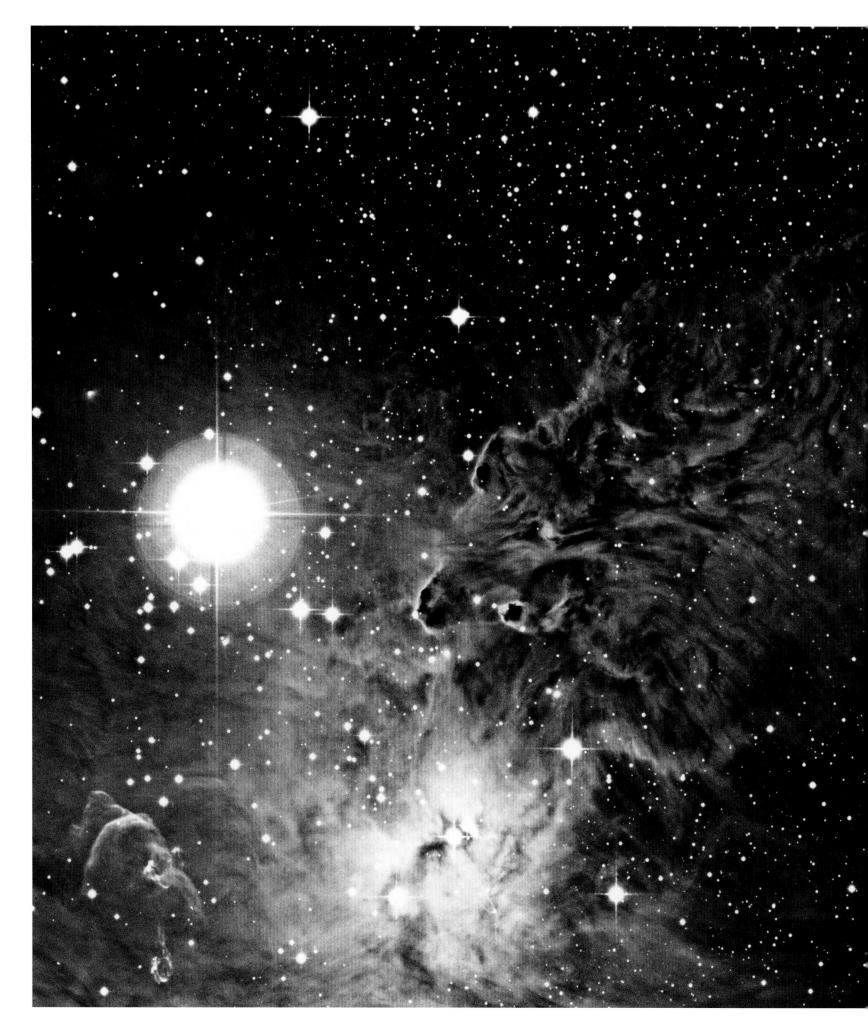

The Fox-fur nebula in Monoceros

<

This curious nebula takes its name from the silky,
striated texture of the faint nebulosity and the fox-
like ears and nose at its eastern end, where it seems
to be flattened among a scattering of stars, gingerly
approaching S Monocerotis, the brightest among
them. The vulpine allusion is enhanced in colour
pictures because the nebulosity is a vivid red. In reality
all we are seeing here are traces of hydrogen mixed
with dust. The overall texture and illuminated edges
of the ears and nose are shadow play in the radiant
glow of S Monocerotis, which is an unusually
massive and luminous star.

NGC 2264 and the Cone nebula in Monoceros

>

The two names imply two objects but in reality they
are intimately associated. The distinctive cone shape
is simply a dark dust cloud with a bright rim which is
itself energized by radiation from the numerous bright
stars in the NGC 2264 star cluster. The whole region is
very dusty –note how the number of faint background
stars varies – and within the dust new stars are
forming, so more bright stars are likely to appear here
to add to the scattered cluster. The most obvious sign is
the curly wisp of light near the top of the photograph,
but many other quite subtle hints are seen near the
Cone nebula, pointing to a vigorous nursery of stars.

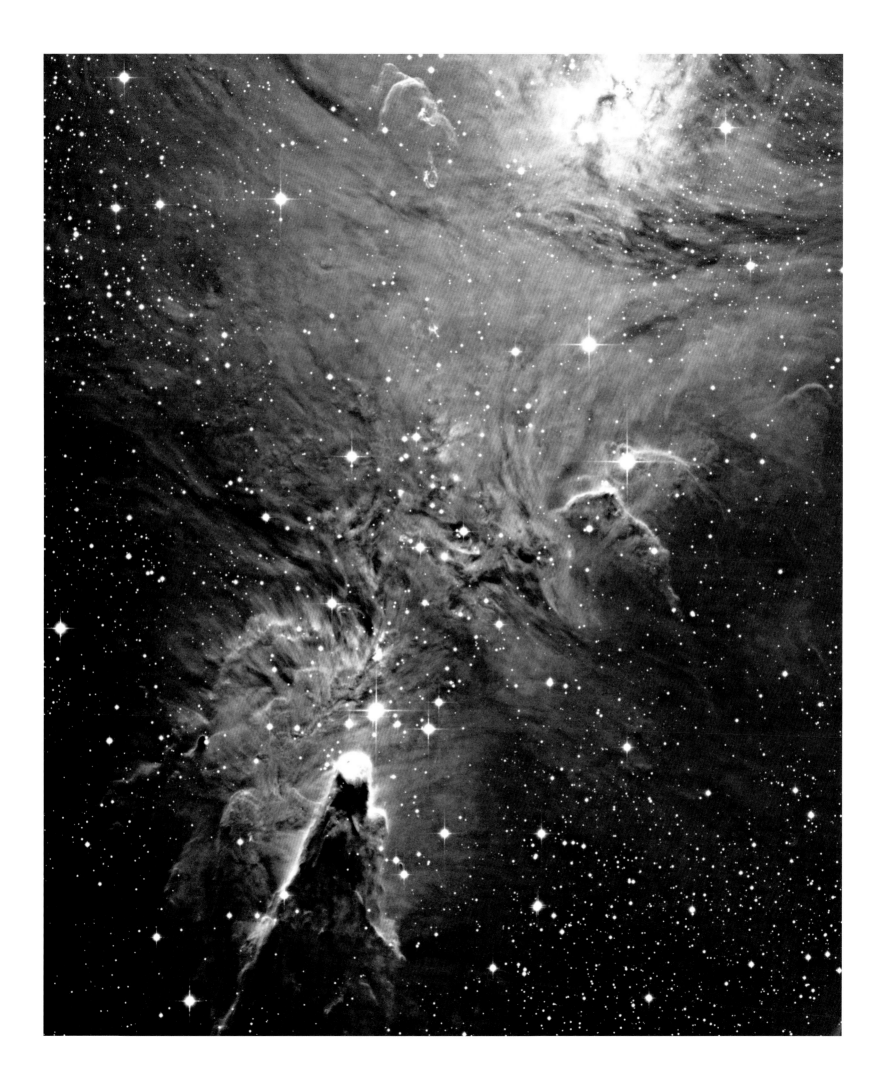

M42, the Orion nebula, and M43 in Orion

>

This is a short exposure image of the Orion nebula
(M42), one of the brightest and best known nebulae in
the sky. The photograph also includes M43, a smaller
nebula at the top of the frame and associated with
M42. One of the nearest starforming regions, the
Orion nebula is 1,500 light years distant and easily
seen during the summer months in the southern
hemisphere. However, the photograph reveals stars
and structures too faint to be seen by eye using any
telescope. The nebula is excited by light of the compact
group of stars at the centre of the nebula, known as
the Trapezium cluster. These are some of the youngest
known stars, formed recently within the glowing gas.
Among the most photographed nebulae in the sky, the
Orion nebula was the first to be captured by the camera
in 1882 by Henry Draper. His pioneering photograph
showed only the brightest inner parts of the nebula
with an exposure of over two hours. The image here is
more like Ainslie Common's photograph of 1883, which
showed much fainter detail.

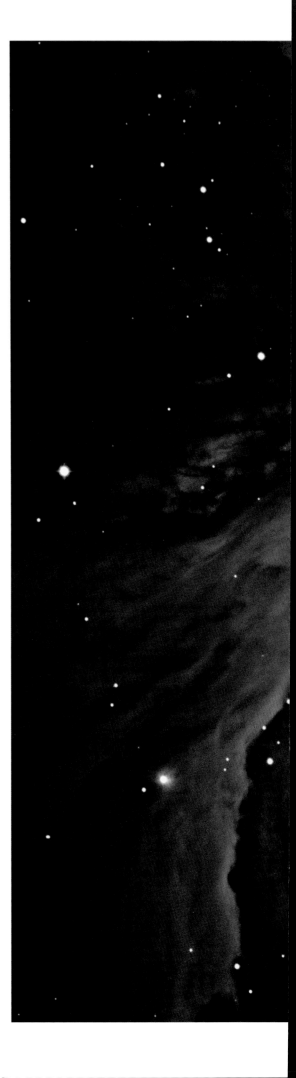

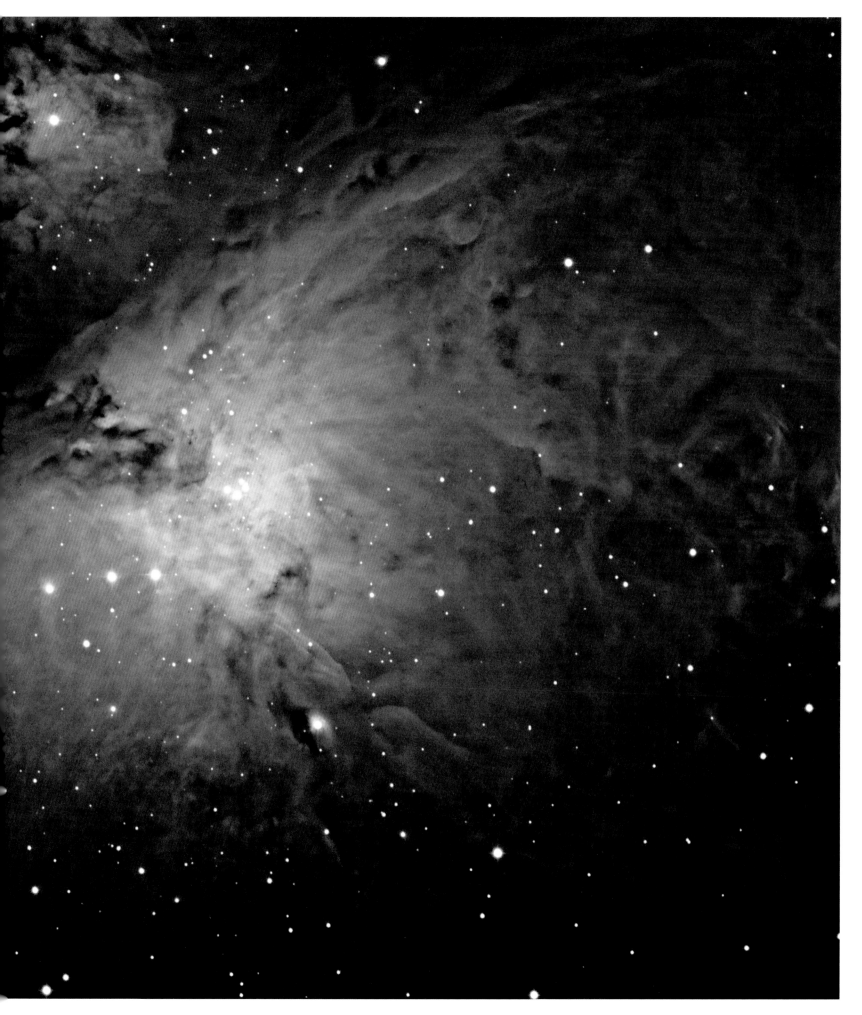

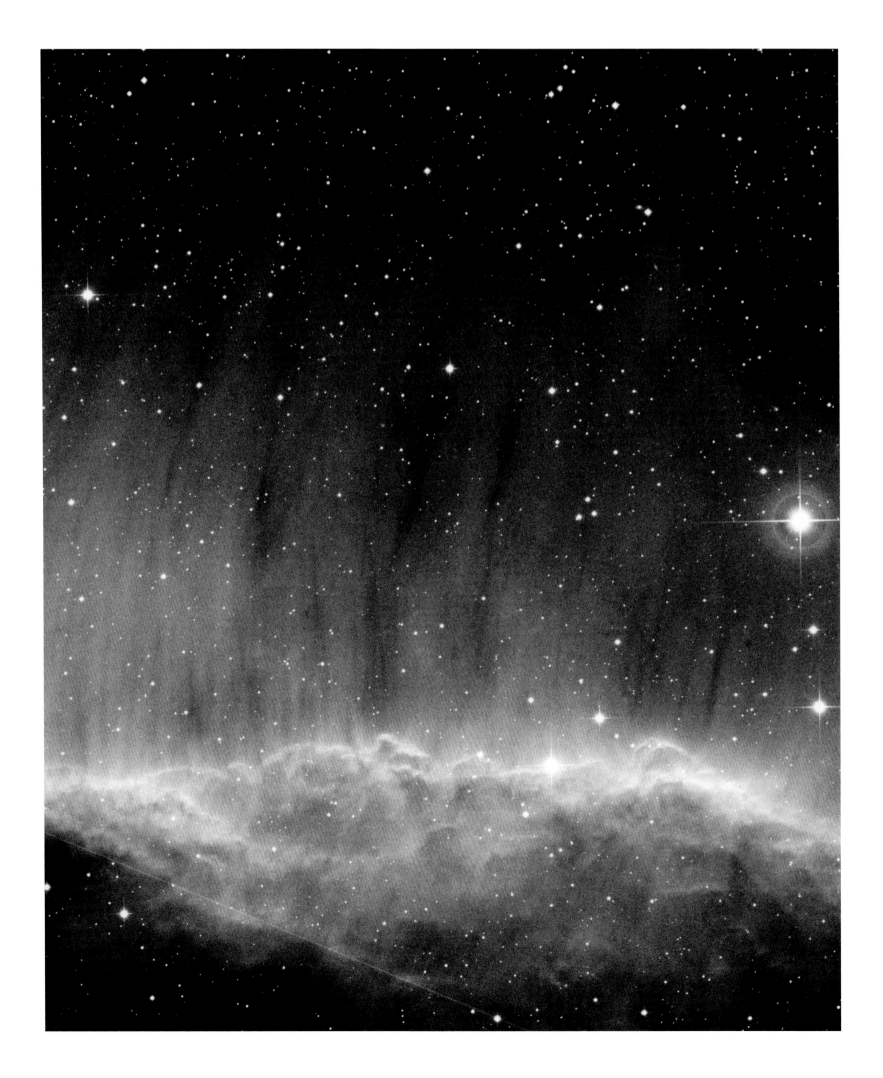

The Horsehead
Molecular Cloud in Orion

<

Between and around the famous Orion and Horsehead
nebulae lies a cold cloud of gas, mostly hydrogen,
mixed with traces of dust. Invisible to the eye, the
molecules of gas are only detected by radio telescopes
and are known as molecular clouds. When the dark
surface of such a cloud is lit by the light from very hot
stars, as here, the energetic radiation makes the gas glow
as it evaporates from the tenuous dust. The starlight
gradually eats into the dust cloud, leaving the luminous,
lumpy surface and wisps of dusty gas emerging from
it, like the spray from a cosmic waterfall.

The Horsehead nebula,
dust and gas adrift in Orion

>

Standing proud, close to the Celestial Equator, in a
rich field of stars lies the iconic Horsehead of Orion.
While this image appears to have substance as well as
style, there is little here that is solid. Most of what is
dark, including the horse's head itself, is little more than
a cosmic smoke-screen made of tiny grains of dust.
The wispy nebulosity that fills the field is tenuous gas,
excited into a glowing plasma by the surrounding stars.
And the stars themselves are also made of plasma,
centrally heated by nuclear furnaces. The Horsehead is
one of the few dark nebulae in the popular catalogue.
We see it because of what it hides, not what it reveals,
and this makes it a very challenging object to see in the
telescope. Obscured is part of a broad strip of structured
nebulosity that extends north–south (left–right) in the
image, and the Horsehead is made of similar dusty
material illuminated in a different way. The shape is a
matter of chance of course, but the protrusion is likely to
be the result of star formation at the base of the dark
shape. The other bright nebula here is a more or less
spherical reflection nebula around a bright star caught up
in the dust that is so abundant in this part of the sky.

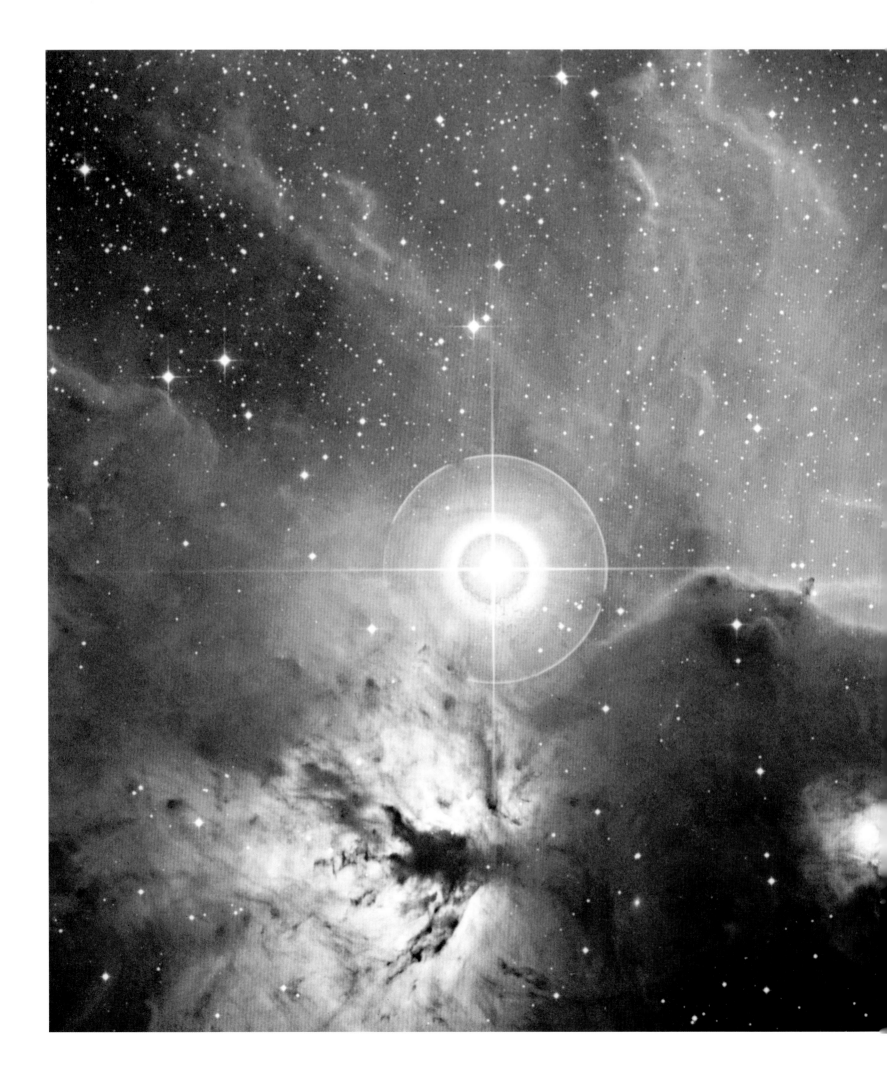

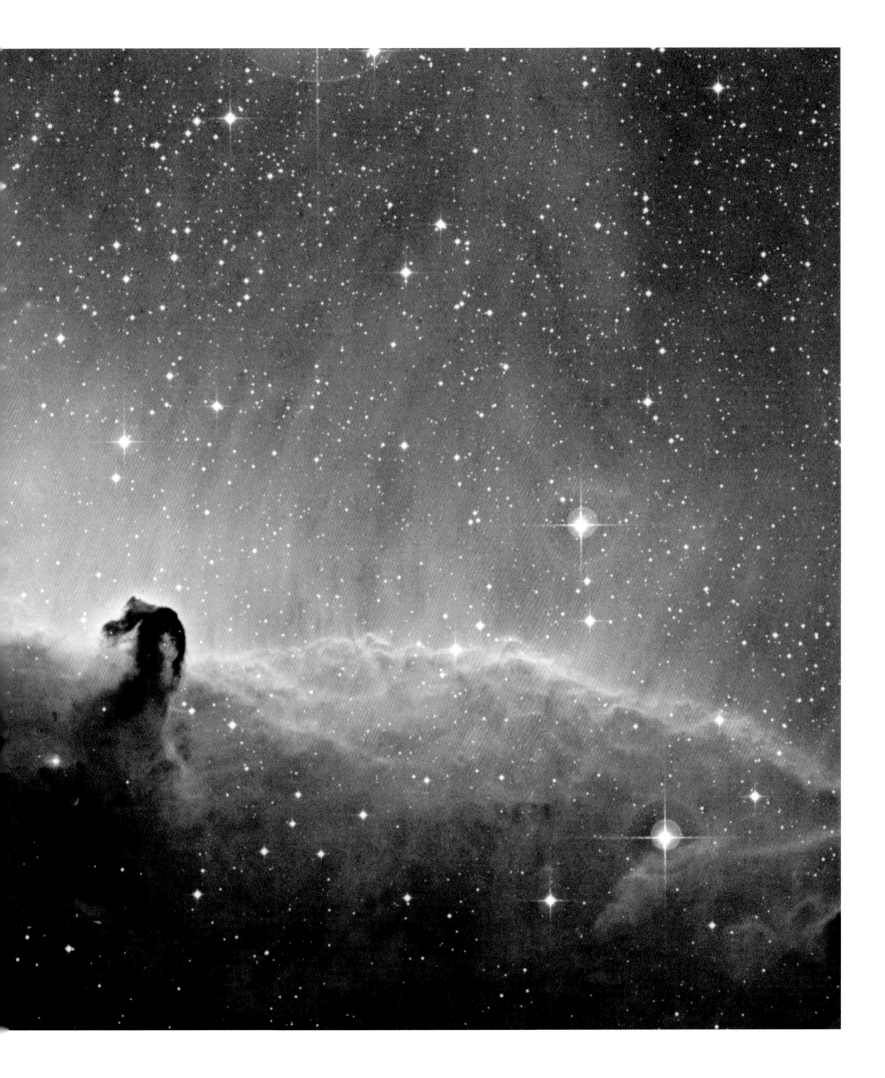

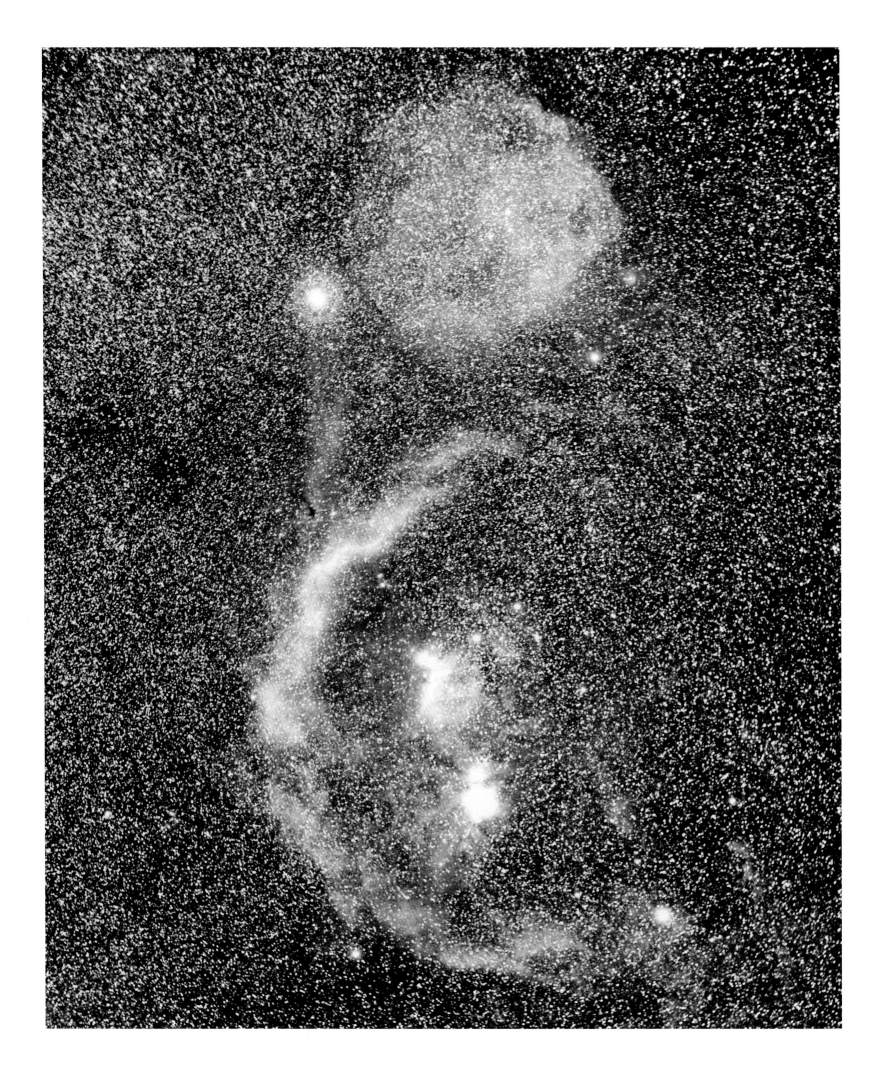

Barnard's Loop in Orion

<

The existence of what is now known as Barnard's
Loop in Orion was suspected by William Herschel in
1786, but was first clearly recognized by the pioneer
astrophotographer E. E. Barnard in the 1890s, who
saw it on one of his plates. It is a large, faint semicircle
of light about 15 degrees across, surrounding the
eastern side of the Orion and Horsehead nebulae.
Stellar winds from the hot stars that have recently
appeared there push away the hydrogen from which
they have formed, creating an expanding cavity whose
rim is marked by the encircling arc. This picture was
made on a glass plate sensitive to red light, using a
two-hour exposure and standard plate camera and
lens attached to a telescope, tracking the stars.

Pleiades stars, wide field, in Taurus
>

These beautiful stars are the Seven Sisters, the
daughters of Atlas and Pleione, watchful parents who
keep their distance. These parents are the two bright
stars to the left (east) of the photograph. As befits their
femininity, the Seven Sisters are shown by modern
telescopes to be masked by a delicate veil. This is dust
in space, a reflection of the stars' light, and it forms
wispy sheets and streaks of light. In keeping with their
ancient origins the girl's names seem remote to us, as
are the stars. Six of the sisters – Maia, Electra, Taygeta,
Alcyone, Celaeno and Sterope – all consorted with
the gods, while the seventh, Merope, not one of the
brightest stars, married a mere mortal, Sisyphus. The
stars of the Pleiades are all much more luminous than
the Sun and are moving together through space 400
light years distant from it. They are in the northern sky
but are visible from all inhabited parts of the Earth,
and are best seen in the early evenings in January. The
delicate beauty of the cluster as seen with the unaided
eye gives rise to legends involving groups of women in
many cultures around the world.

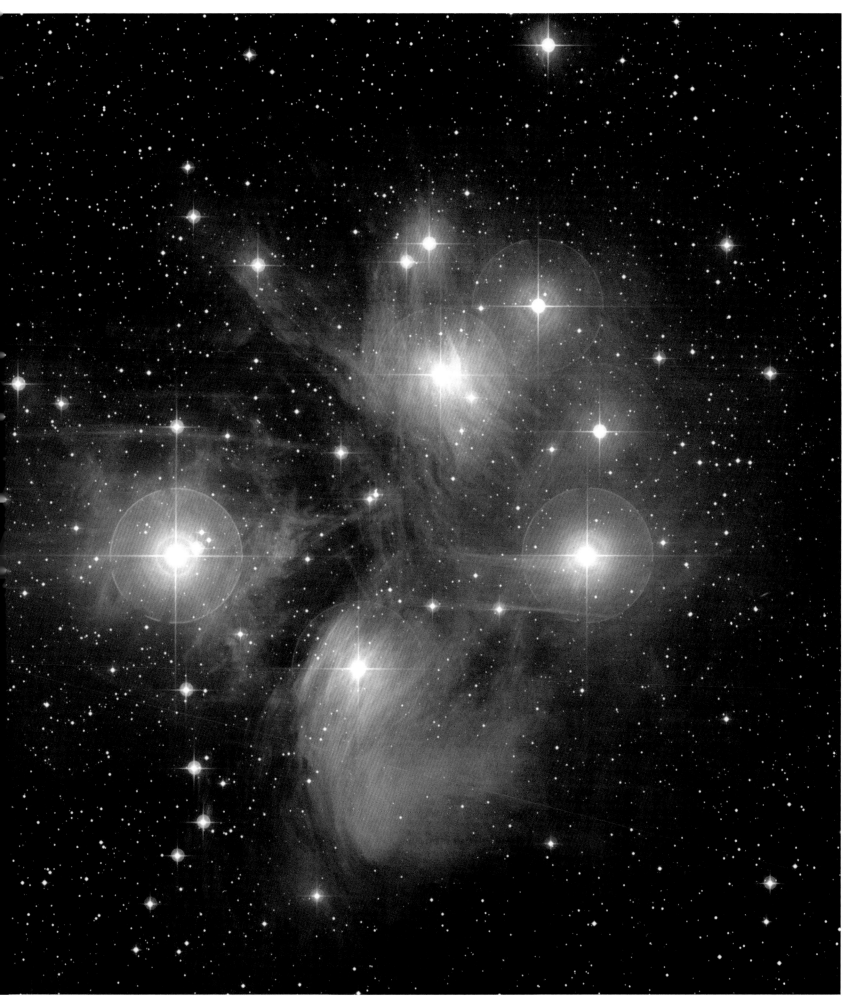

>

Since ancient times the constellation of Andromeda has been depicted as representing a female form. In Greek mythology Andromeda was the daughter of Cepheus and Cassiopeia, the king and queen of the Phoenician kingdom of Ethiopia. As punishment for her mother's arrogance, Andromeda was chained to a rock as a sacrifice to Cetus, then rescued by Perseus whom she subsequently married. The distinctive asterism in the form of a W to the north of Andromeda is the reclining Cassiopeia, whose stars spread across a faint stretch of the Milky Way. In the middle of the modern outline of Andromeda lies a galaxy that has taken her name. The elongated form of M31, the galaxy in Andromeda, is visible to the unaided eye and is a majestic spiral system rather similar to the Milky Way in form and size, but seen almost edge-on and from a distance of about two million light years. The images in this section include a wide-angle photograph of the galaxy and a detailed view of its central bulge. In the adjoining constellation of Triangulum and at a distance similar to that of M31 is another beautiful spiral galaxy, M33, the galaxy in Triangulum. This is seen almost face-on, allowing us to see the brilliant star clusters defining the spiral arms.

Cassiopeia's Daughter & the Nearest Spiral Galaxies

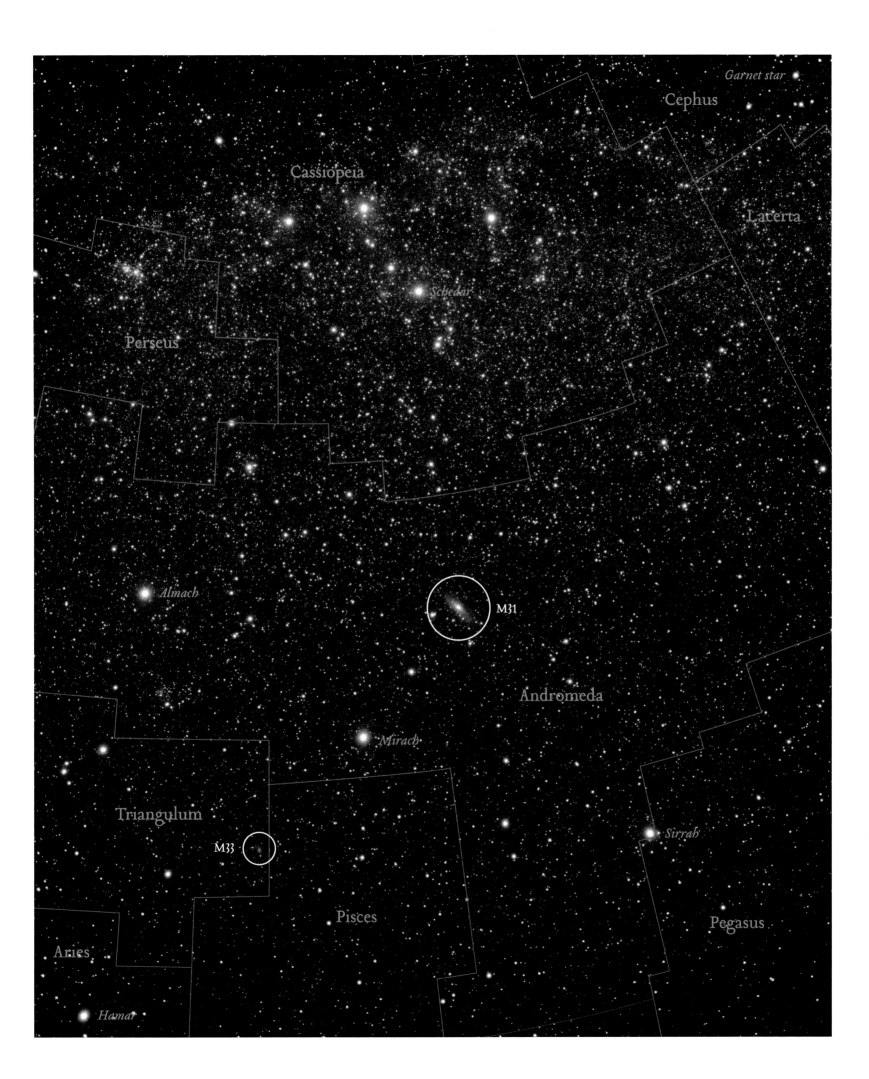

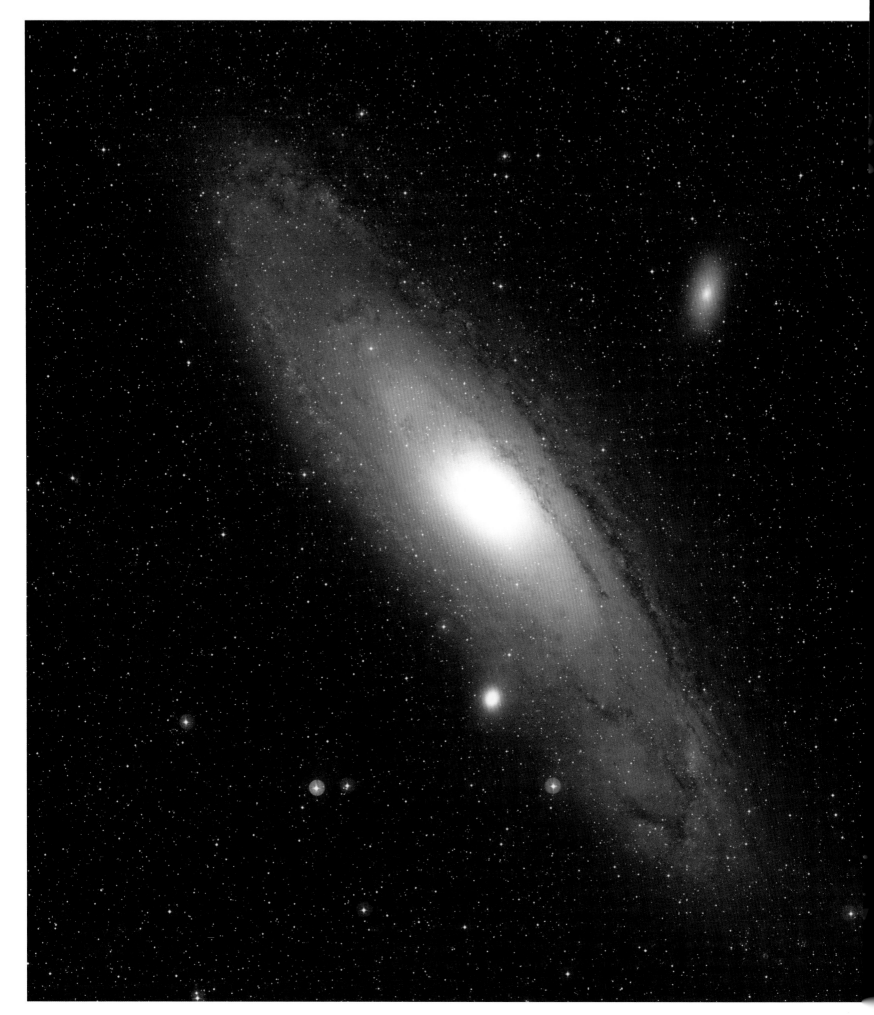

M31, the galaxy in Andromeda

<

The Andromeda galaxy, M31, is over two million light years away. Despite this enormous distance it is visible to the unaided eye and was first noted by the Persian astronomer Al Sufi in about AD 905. It is now known to be the nearest spiral system to our own galaxy, the Milky Way, knowledge gleaned from photographic plates in the 1920s. This image was made in 1978 on the (then named) Palomar Schmidt Telescope and shows the two bright companions to M31. These are elliptical galaxies, fuzzy shapes that are mostly devoid of the gas, dust and bright arcs of young stars that make spiral galaxies so distinctive.

The central regions of
M31 in Andromeda
>

In many ways like our own galaxy, M31 is a giant
spiral galaxy with extensive but relatively faint spiral
arms sprinkled with bright stars and streaked with
dust. The centre of this image is dominated by the
much brighter inner part of the galaxy, into which the
dust lanes seem to spiral. The bright central light is
a gathering of vast numbers of faint, old stars. Within
this central nucleus, and unseen in this photograph,
lies a massive Black Hole. Seen from a similar distance
(two million light years), the central parts of our
own galaxy probably look rather similar.

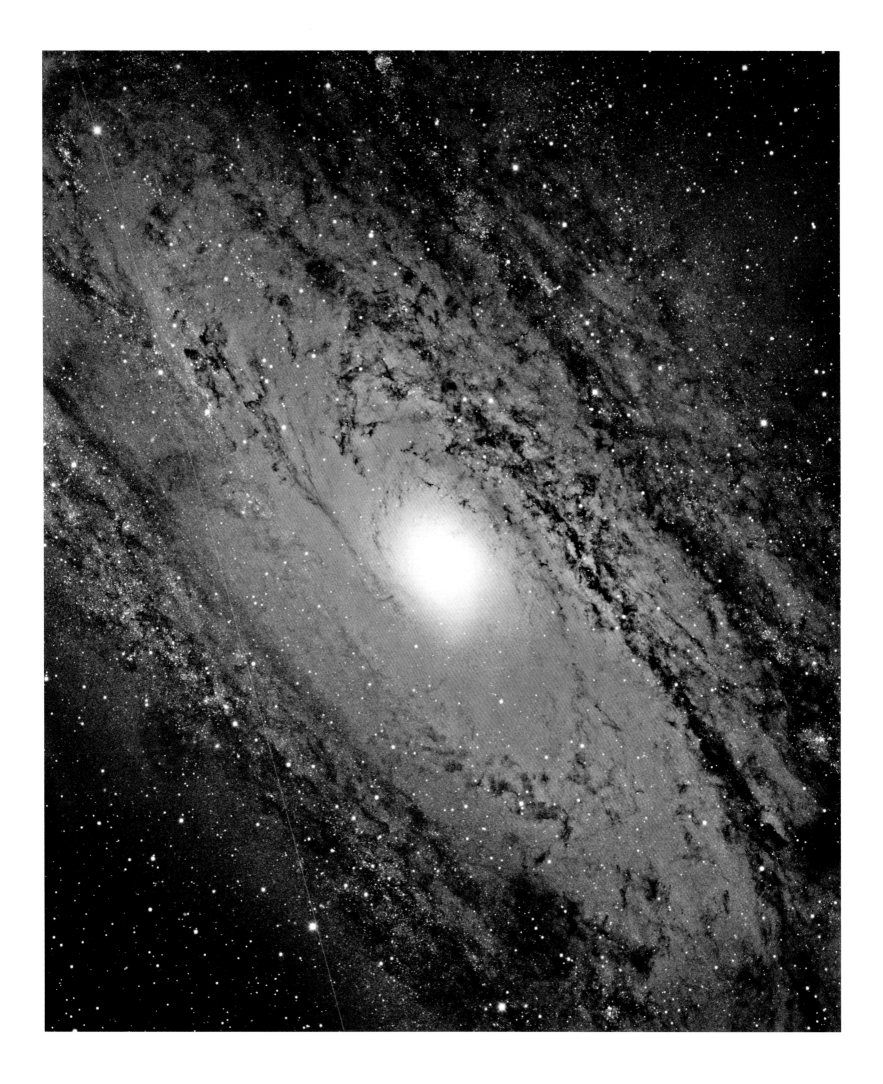

M33 (NGC 589), the galaxy
in Triangulum
>

This beautiful spiral galaxy was first noted by Charles
Messier in 1764, and under ideal conditions it is visible
to the unaided eye in the northern sky. It is seen from
a distance of three million light years and is thus one
of the most distant naked-eye objects. It is also one
of the most massive members of the Local Group,
a loose scattering that includes the Milky Way and
30 or so other galaxies that are mostly quite faint.
Photographed with a modest telescope, M33 is close
enough for the brightest stars to be seen as individuals,
mostly in young star clusters, as is visible in this
photograph taken in blue light.

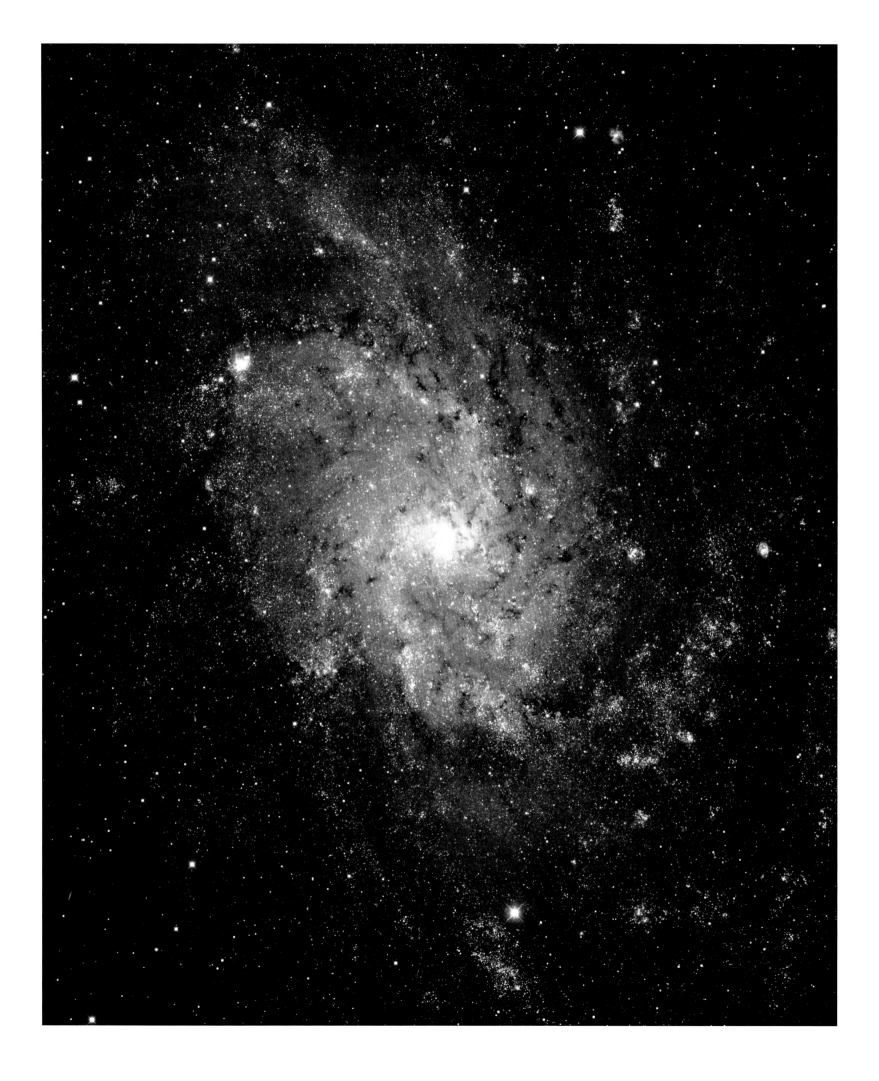

Index

Page numbers in *italic* refer to the illustrations

Technical information about the photographs

The telescopes used to make these exposures have been listed as follows:
AAT: Anglo-Australian Telescope; KPNO: Kitt Peak 4m Telescope;
PS: Palomar Schmidt Telescope; UKS: UK Schmidt Telescope

> Page	Telescope, source	Emulsion, exposure
2	AAT, plate R2427	098-04, 20 minutes
4	AAT, plate Ha1147	IIIa-F, short
12	AAT, plate V747	IIa-D, 45 minutes
15	4 x 5 view camera	IIIa-F, 615 minutes
18	AAT, plate Ha1147	IIIa-F, less than 1 minute
20-21	UKS, plate B10848	IIa-O, 15 minutes
23	UKS, plate BF16993	Tech Pan, 18 minutes
26	AAT, plate R2780	IIIa-F, 3 minutes
28-29	AAT, plate R2765	098-04, 12 minutes
31	3 x AAT plates, B+V+R	100 minutes overall
32	AAT, plate B2581	IIa-O, 40 minutes
35	AAT, plate J1739	IIIa-J, 80 minutes
37	AAT, plate R1636	IIIa-F, 90 minutes
41	AAT, plate J2089	IIIa-J, 90 minutes
43	3 x AAT plates, B+V+R	85 minutes overall
44	Subtraction of 2 x 2 AAT plates	IIa-D, 098-04, 13 minutes overall
47	3 x AAT plates, B+V+R	80 minutes overall
50-51	UKS, plate R3443	IIIa-F, 90 minutes
53	AAT, plate B2851	IIa-O, 1 minutes
54	AAT, film C1365	colour film, 42 minutes
56-57	3 x UKS plates, B+V+R	220 minutes overall
59	AAT, plate R2487	098-04, 24 minutes
60	3 x AAT plates, B+V+R	85 minutes overall
64	AAT, plate R2308	098 04, 35 minutes
67	UKS, plate J1117	IIIa-J, 33 minutes
68	AAT, plate R2772	IIIa-F, 90 minutes
69	AAT, plate R2772	IIIa-F, 90 minutes
71	UKS, plate Ha17473	Tech Pan, 120 minutes
73	3 x AAT plates, B+V+R	100 minutes overall
76	KPNO+AAT plates	IIIa-J, 45 minutes
79	AAT, plate J2090	IIIa-J, 90 minutes
80	AAT, plate J1789	IIIa-J, 90 minutes
82-83	AAT, plate V2305	IIIa-F, 55 minutes
84	AAT, plate J2405	IIIa-J, 90 minutes
86-87	3 x AAT plates, B+V+R	70 minutes overall
91	AAT, plate B2472	IIIa-J, 85 minutes
93	AAT, plate B89	IIa-O, 60 minutes
94	UKS, plate J645	IIIa-J, 50 minutes
95	UKS, plate J645	IIIa-J, 50 minutes
96	AAT, plate B2389	IIa-O, 30 minutes
99	AAT, plate B2389	IIa-O, 30 minutes
103	UKS, plate J9753	IIIa-J, 80 minutes
104	AAT, plate R2302	IIIa-F, 90 minutes
107	AAT, plate R2302	IIIaF, 90 minutes
109	AAT, plate V1650	IIa-D, 5 minutes
110	AAT, plate R2290	098-04, 35 minutes
112-13	UKS, plate R3816	IIIa-F, 90 minutes
114	4 x 5 view camera	IIIa-F, 120 minutes
117	UKS, plate J5359	IIIa-J, 70 minutes
120	Palomar Schmidt plate, PS25384	not known
123	KPNO, plate J680	IIIa-J, 45 minutes
125	KPNO, plate J3840	IIIa-J, 45 minutes

Frontispiece:
This image was made on the night of 9 December 1985 as Comet Halley
headed towards the inner solar system after a journey that took it as
far from the Sun as the planet Neptune. Halley will return to the chill
of deep space beyond Neptune in 2024 before returning again in 2061.
To make this 20-minute exposure, the telescope was programmed
to track the head of the comet as it moved across the sky so that
the background stars appear as parallel streaks. The image was made
in red light to emphasize the dust tail that formed as the comet
approached the Sun, whose light the tiny particles reflect.

> Phaidon Press Limited
Regent's Wharf
All Saints Street
London N1 9PA

Phaidon Press Inc.
180 Varick Street
New York, NY 10014

www.phaidon.com

First published 2009
© 2009 Phaidon Press Limited

ISBN 978 0 7148 4932 4

A CIP catalogue record for this book is available
from the British Library.

Designed by Frost Design
Printed in China

I am grateful to Denise Wolff for suggesting that a book of black and
white astronomical photographs would be a good thing to do. She was
moved to think about this after seeing an exhibition of my platinum prints
that was organized by my long-time associate Howard Schickler, who
had encouraged me to make some platinum prints of astronomical objects.
I was very pleased to be able to include as section location maps some
wide-angle images of the sky made by Akira Fujii, whose constellation
images I greatly admire. I thank friends and colleagues at the Anglo-
Australian and UK Schmidt Telescopes for the use of material from those
plates I did not take myself, and for their support over many years.
Finally I am grateful to Alexandra Stetter and her colleagues at Phaidon Press
for the care and diligence at every stage in the preparation of this book.